ABANDONED
CLEVELAND

ABANDONED
CLEVELAND

JEFFREY STROUP

AMERICA
THROUGH TIME®
ADDING COLOR TO AMERICAN HISTORY

For Kaylah, your love and support is everything.

America Through Time is an imprint of Fonthill Media LLC
www.through-time.com
office@through-time.com

Published by Arcadia Publishing by arrangement with Fonthill Media LLC
For all general information, please contact Arcadia Publishing:
Telephone: 843-853-2070
Fax: 843-853-0044
E-mail: sales@arcadiapublishing.com
For customer service and orders:
Toll-Free 1-888-313-2665

www.arcadiapublishing.com

First published 2018

Copyright © Jeffrey Stroup 2018

ISBN 978-1-63499-078-3

Typeset in Trade Gothic 10pt on 15pt
Printed and bound in England

CONTENTS

INTRODUCTION

I n the 1950s, Cleveland's population peaked at just under one million. By the year 2000, that number had been nearly cut in half. A fifty-percent drop in population over fifty years left the city in an almost ghost-town-like state. Adding insult to injury, during the recession of 2008, Cleveland's Slavic Village neighborhood saw the highest number of foreclosures in the country. This dramatic decline in population led to an abundance of schools without enough students, churches with only a handful of parishioners, stores with no customers, and homes with no occupants. It was not long before doors were permanently closed, windows were boarded, and once beautiful structures were left to rot.

As a kid growing up in the suburbs, I knew nothing of the darkened industrial giants or the blocks of vacant houses. Instilled with a drive to explore the unseen areas of my surroundings, my friends and I spent our summer days exploring the woods and poking around in the storm drains that ran beneath our neighborhood. This was my first foray into the world of urban exploration. In my late teens, I remember making trips to Cleveland for concerts; driving into the city I would see all of the bridges, factories, and miles and miles of unfamiliar city streets. I would be overcome with the need to explore them. I wanted to know all of the city's secrets.

By 2004, I already carried a camera with me everywhere I went. After seeing photos online of abandoned factories in Detroit and the crumbling Kirkbride asylums of New England, I realized the city's secrets could be mine for the taking. I assembled a group of friends to join me on ventures into Cleveland to explore and photograph whatever abandoned buildings we could find. The possibilities were limitless in those early years. There were times that we would park the car and walk from one abandoned building to the next, sometimes exploring three or four buildings before needing to move onto another area. However, it wasn't long before Cleveland started to change.

It seemed like overnight the empty storefronts turned to restaurants and our favorite buildings fell victim to the wrecking ball. There is still a long way to go, but Cleveland has already made huge strides in its rise from the ashes. It may never be the same city that

John D. Rockefeller once called home, but it has shown that it will not go down without a fight. Today Cleveland's downtown occupancy rate is roughly ninety-five percent. New development is a constant threat to the remaining monuments of the city's past. This threat continues to push me to document these places before they are gone. The places in this book are not merely a part of Cleveland's history, they are a part of our history. Places where families ate together, neighbors gathered to worship, and friends worked side by side to produce goods. These places are not simply structures from the past; they have stories to tell, stories worth remembering, and that is what this book is about.

1

INDUSTRY

If there is one thing that embodies the spirit of Cleveland, it is industry. Steel mills, smoke stacks, and enormous factory buildings still litter the landscape. On July 22, 1796, Moses Cleavland and his surveying party came ashore where the Cuyahoga River meets Lake Erie; he knew that this would be the perfect location for a great city. Both the river and the lake have been vital to the city ever since. The water access made it an ideal location for manufacturing.

One of Cleveland's most well-known abandoned factories is the Westinghouse building, as it is commonly known. It's a massive old power plant and for a short while getting into the building required climbing up onto the elevated railroad tracks that run along the eastern side of the building and going through an open door on a long steel loading dock. Within a few years, that loading dock was gone. A few years after that, a large portion of the buildings in the middle of the complex were also gone. It is amazing to watch these buildings change over the years. These places become part of us—like old friends that we don't visit as often as we should, and when we do we are struck by how they have aged.

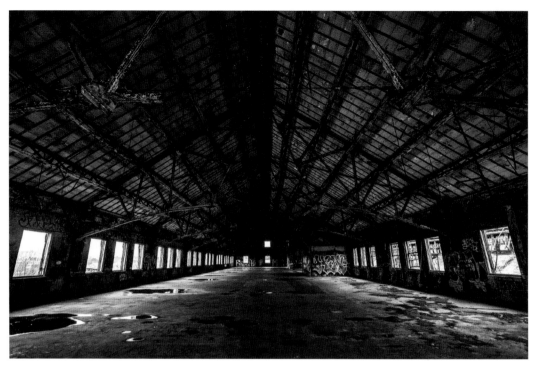

This massive factory complex dates back to 1888. It has served many uses over the last century; however, it was originally the Cedar Avenue Power Plant for the Cleveland Railway Company. (2018)

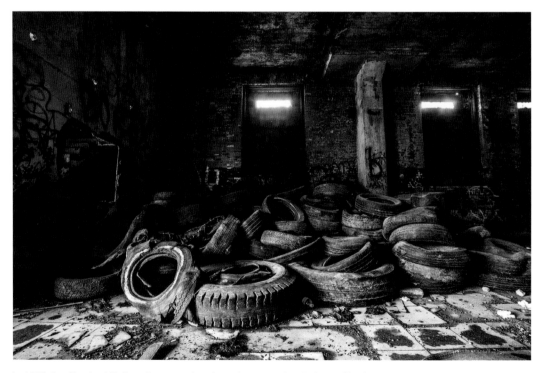

In 1917, the Cleveland Railway Company shut down the power plant in favor of buying power instead of generating their own. The building was then used by the Cleveland Ice Machine Company and then Westinghouse Electric. In 1933 Westinghouse moved their operations to West 58th Street along the Shoreway. (2018)

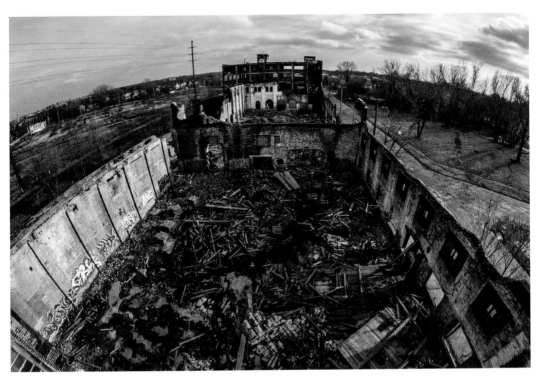

The middle section of buildings were partially demolished. I had assumed that the rest of the building would soon come down as well; thankfully, that still hasn't happened. (2015)

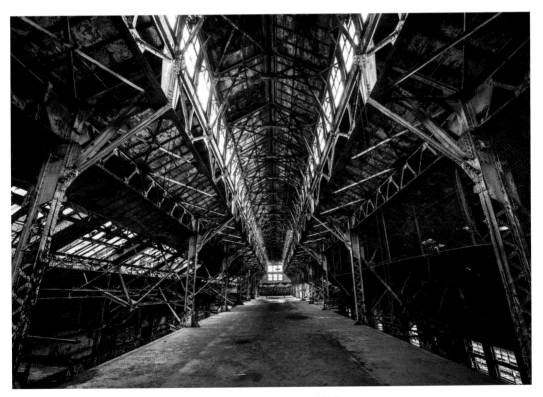

A scene from the movie *The Avengers* was filmed in this room. (2018)

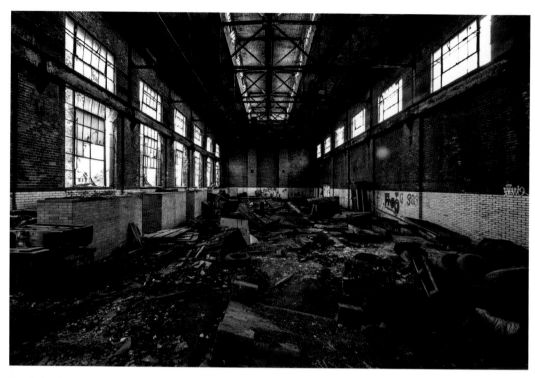

The Cedar Avenue Substation was built in 1917 and closed in 1948. This powerhouse supplied electricity to the Cleveland Railway streetcars. (2018)

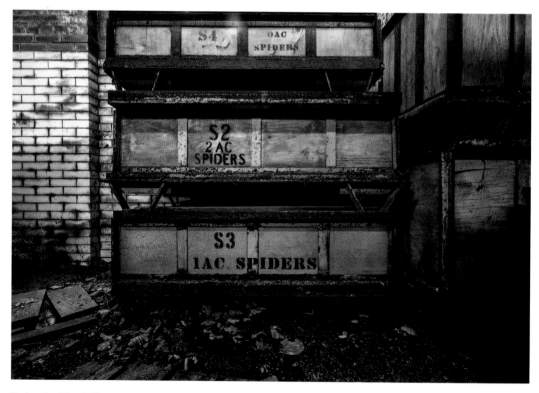

Crates of spiders in the empty substation. (2018)

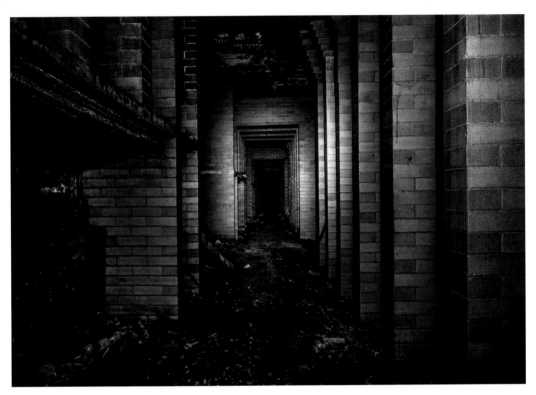

Narrow corridor in the basement of the substation. (2018)

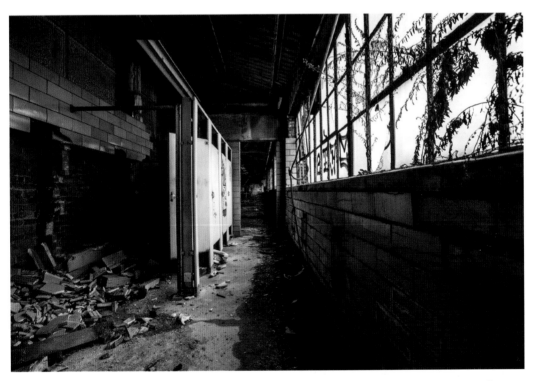

The National Acme building was constructed in 1917 and was once one of the largest machine tool manufacturers in the country. (2018)

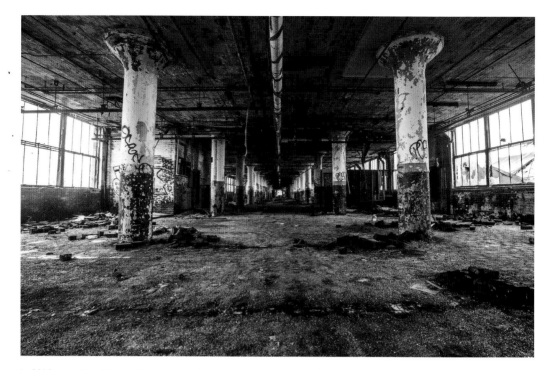

In 2012, a portion of the building was demolished without properly removing the asbestos. To make things even worse, a garbage hauling company illegally dumped 40,000 tons of household trash inside the building. In the summer, the stench of all that rotting trash can be nauseating. (2018)

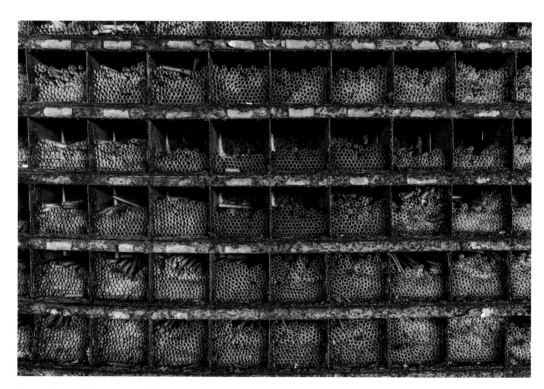

I've made several visits to this building, the first being in January of 2011. I've taken this same photo every time. I'm surprised these haven't been scattered all over the building by now. (2018)

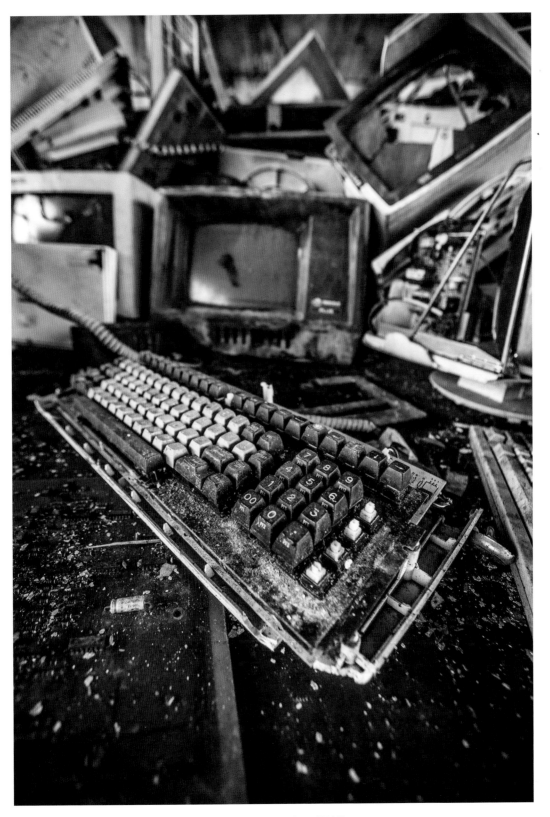

A pile of old computers sitting in the middle of the factory floor. (2018)

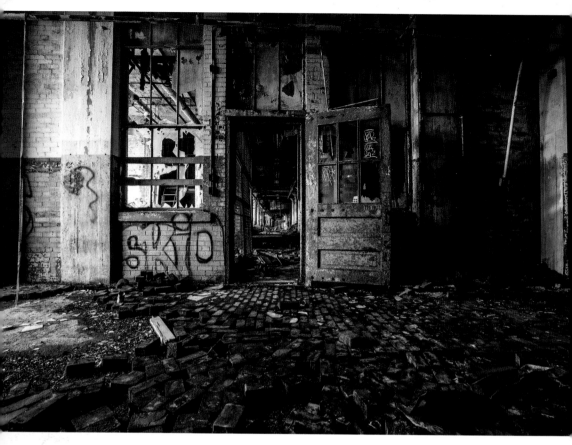

The first time that I explored this building, this corridor had twelve enormous boilers, six on each side. (2018)

Opposite page: End grain flooring such as this was popular in the 1920s. There are several factories in the city where you can find floors paved with wooden bricks like these. (2018)

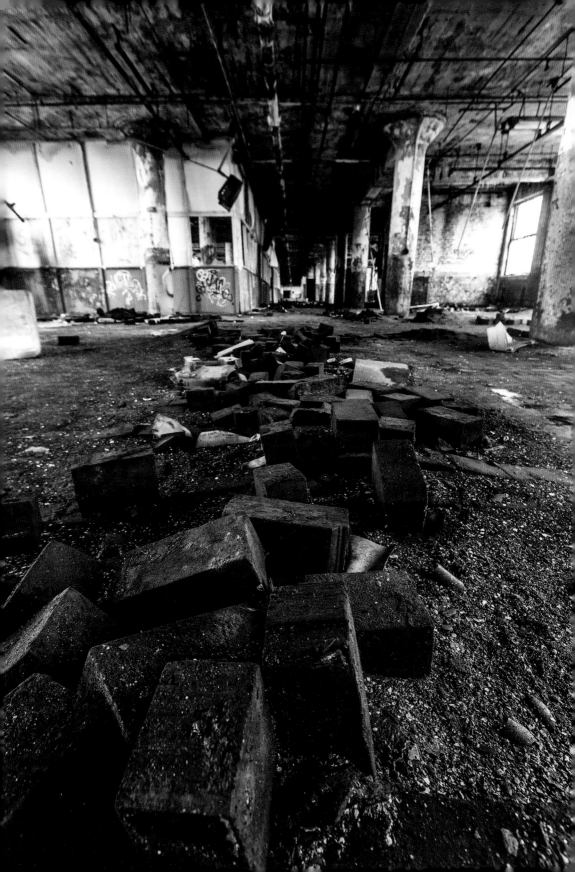

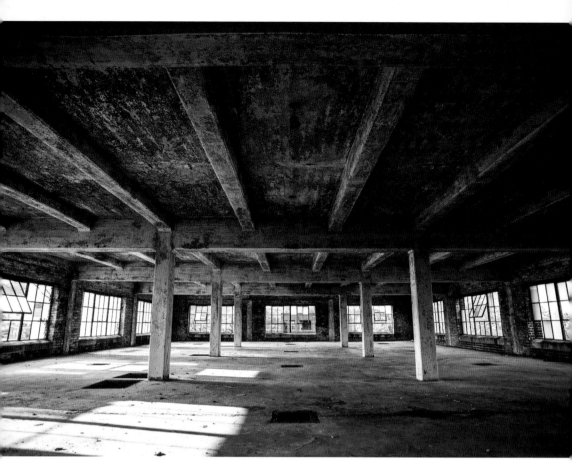

This small factory was built in 1910. The top floor has shoots that fed into hoppers on the ground floor. (2014)

Opposite page: This factory was built in 1896 for the Chicago Pneumatic Tool Company. (2014)

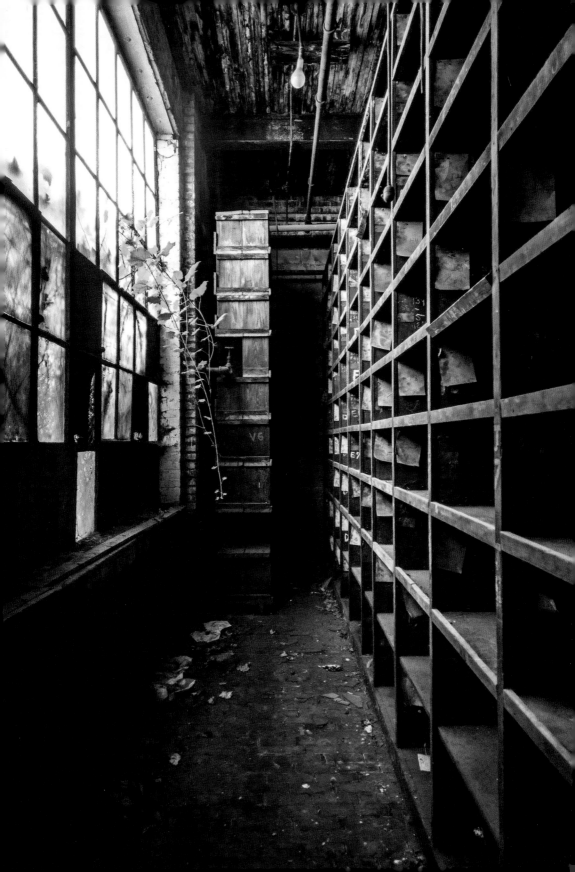

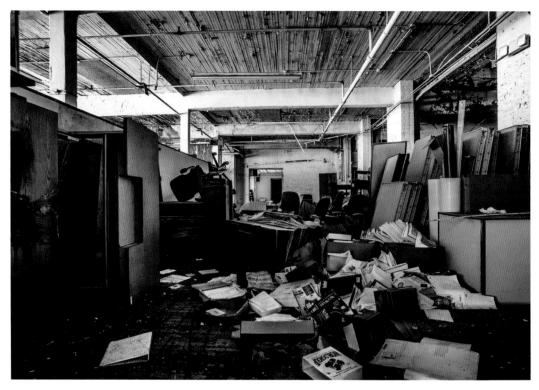

One floor was filled with office furniture and cubicle partitions. Another floor had several old arcade games. (2014)

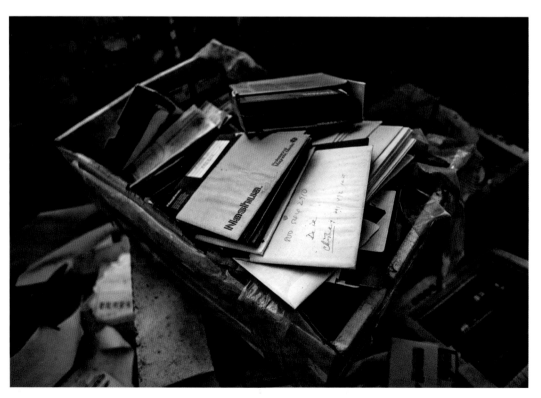

Boxes of floppy disks. (2014)

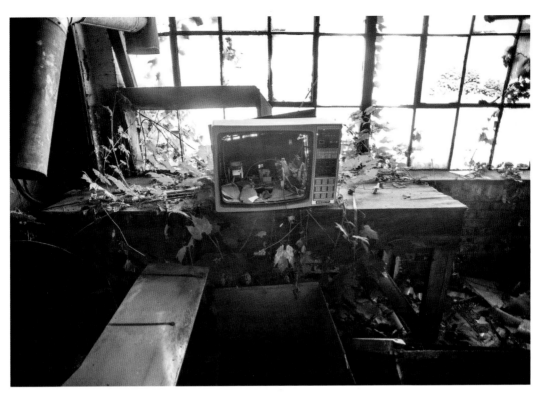

Vines growing around a broken television. (2014)

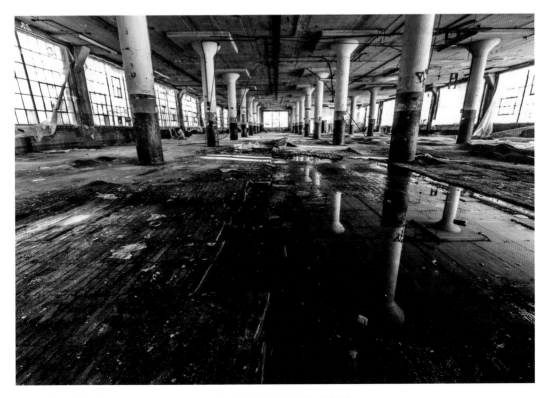

The White Dove company began producing mattresses in 1922. (2017)

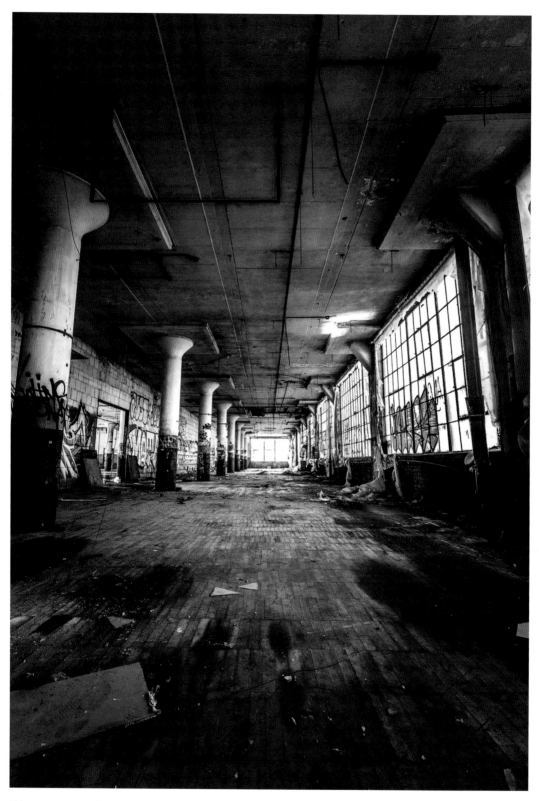

This room was once filled with industrial sewing machines. (2017)

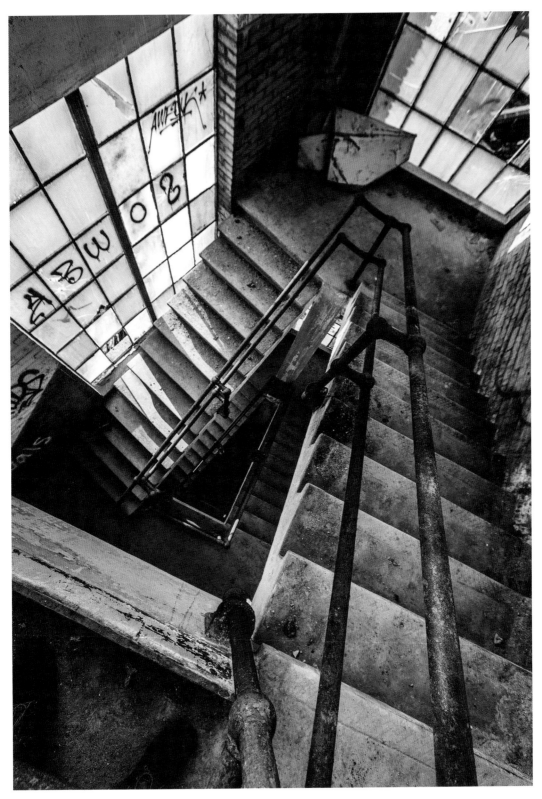

Train tracks once wrapped around the back of this building, which restricted its eastern-most corners. This restriction led to unusual angles and triangular stairwells. (2017)

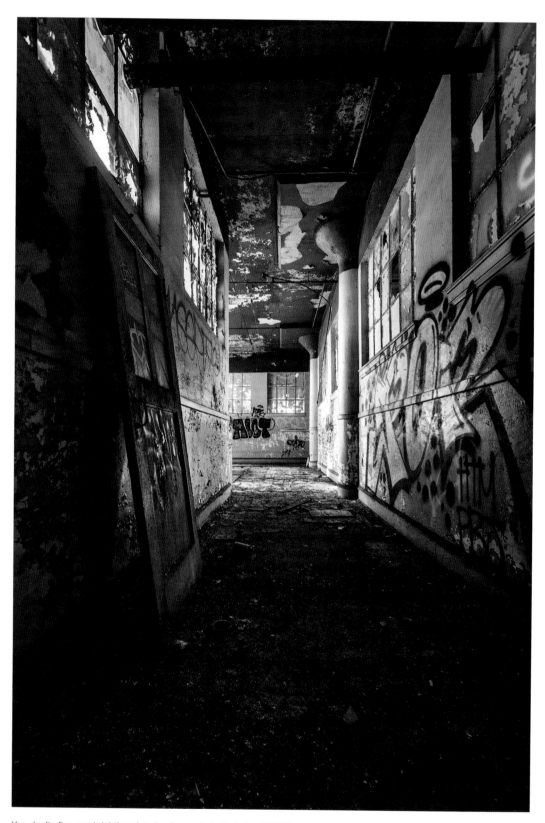

You don't often see brightly painted yellow walls in factories. (2017)

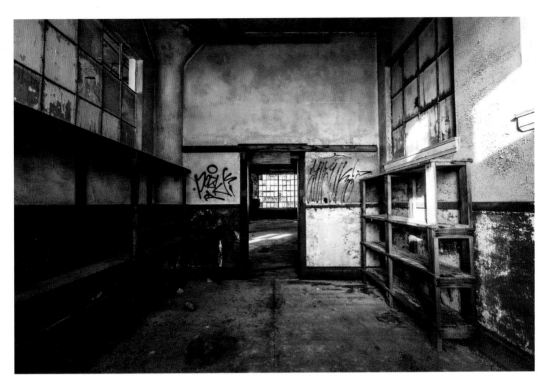

The factory building seems to be in relatively decent shape, at least in comparison to the city's other vacant industrial buildings. (2017)

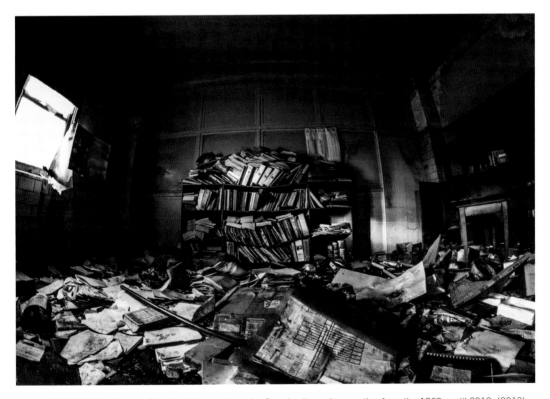

The T&B Foundry was Cleveland's longest running foundry. It was in operation from the 1860s until 2012. (2013)

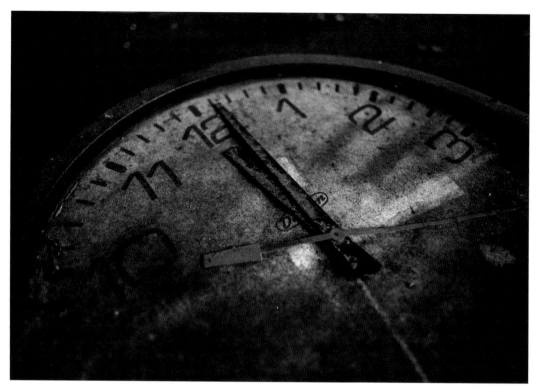

A clock lays on the floor of an abandoned factory. Its hands permanently stopped at 12:01. (2014)

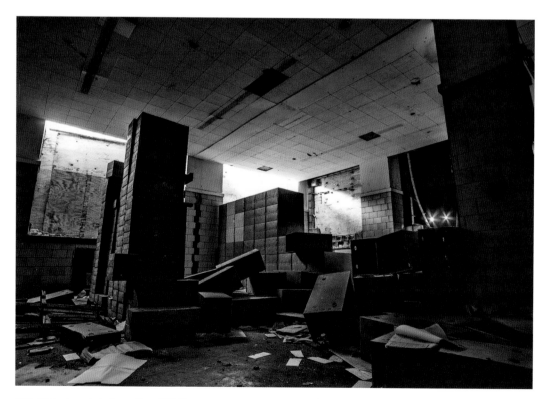

Files stacked nearly to the ceiling. (2014)

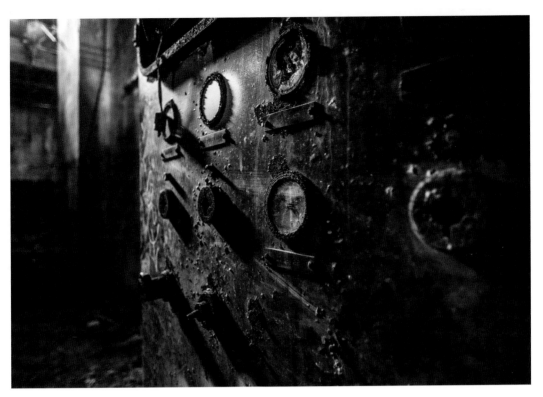

Pressure gauges in the boiler room of the Cloth Craft building. It was built in 1907, and Joseph & Feiss made suits here until they shut down the factory in 1997. The building has since been renovated into a school. (2014)

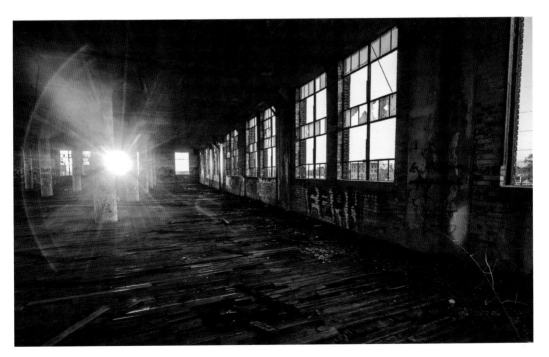

Above: Sunrise between mushroom columns in an abandoned garment factory. (2015)

Next page: A stairwell in the Cloth Craft building. (2014)

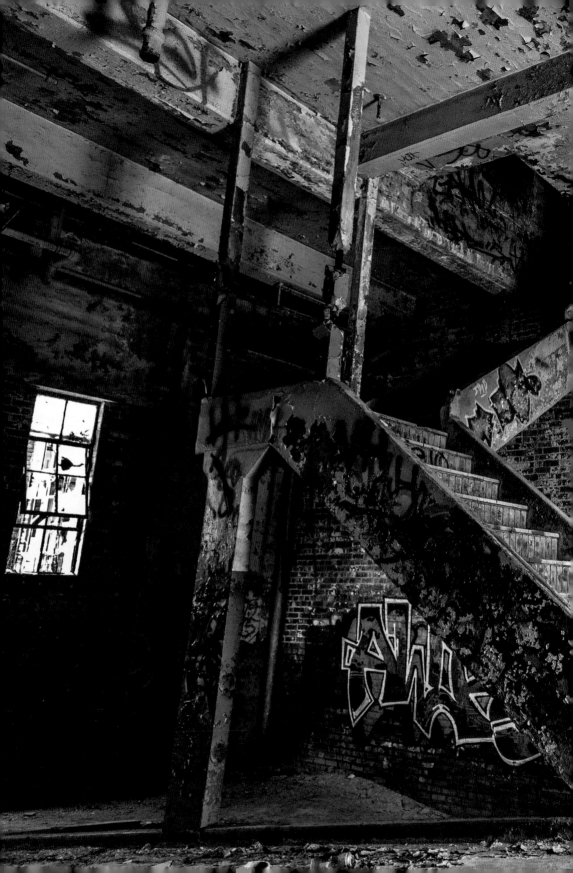

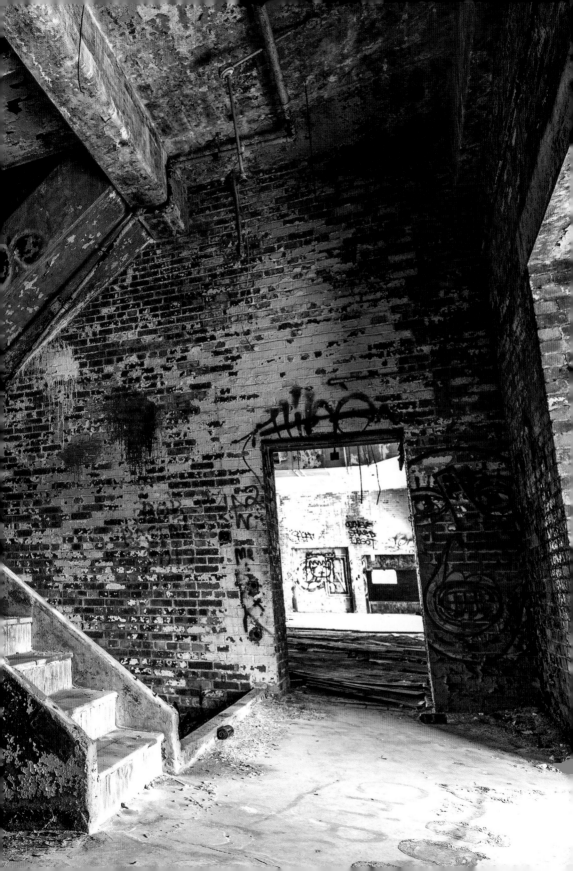

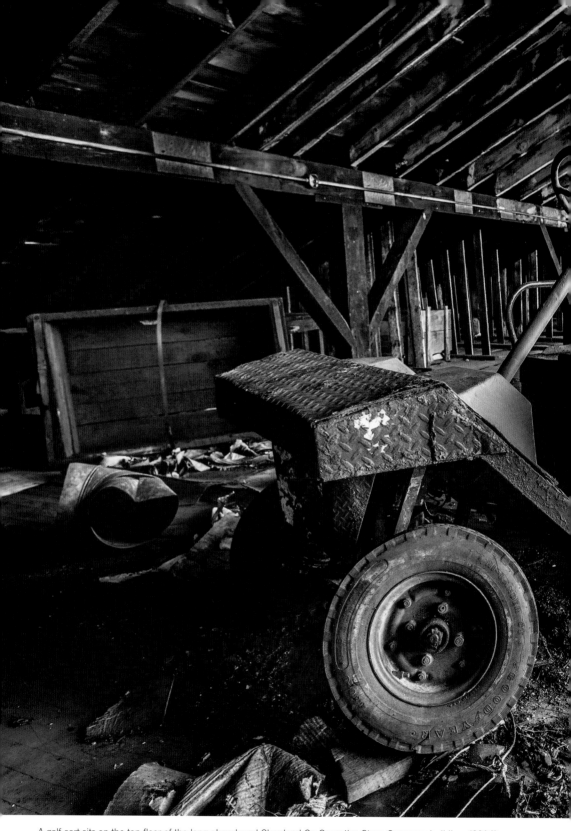

A golf cart sits on the top floor of the long-abandoned Cleveland Co-Operative Stove Company building. (2014)

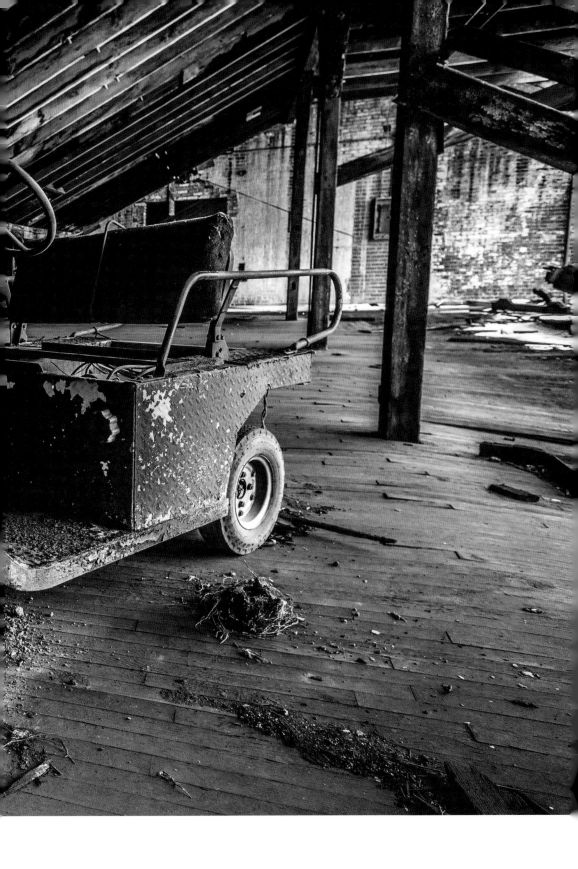

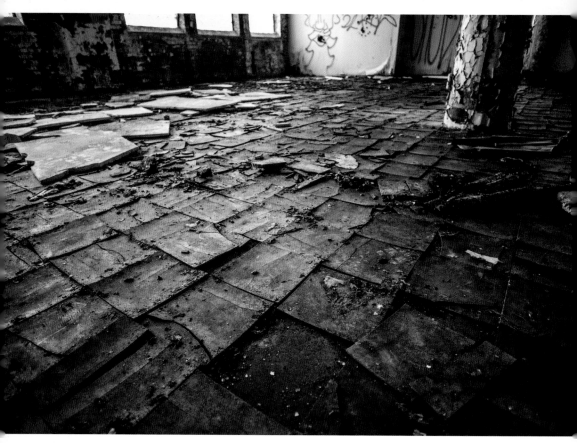

This building served a number of companies throughout the last century, including the Clark Controller Company, and Victoreen Instrument Company. Victoreen produced radiation detectors for the Manhattan Project. (2014)

Opposite page: Founded in 1928 by John Austin Victoreen. Up until 1946, Victoreen was the only manufacturer of nuclear detection instruments. (2014)

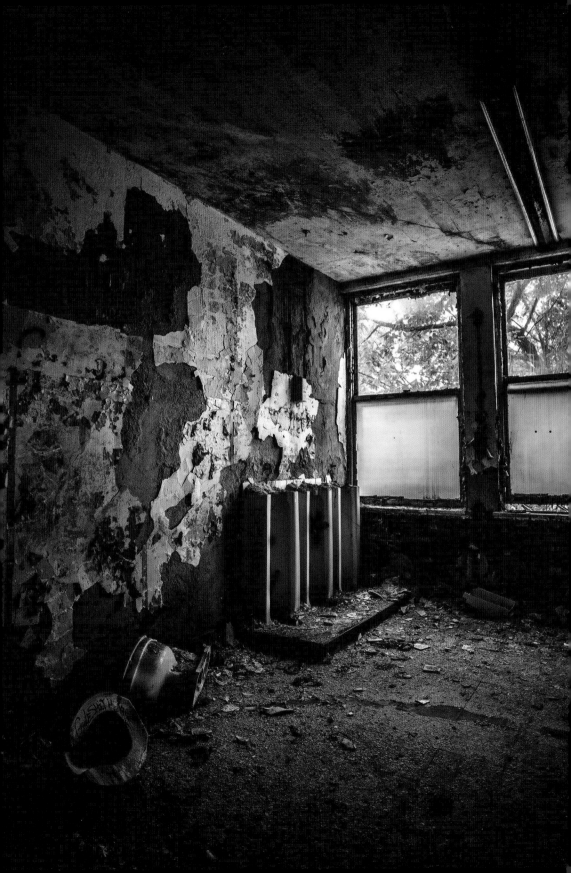

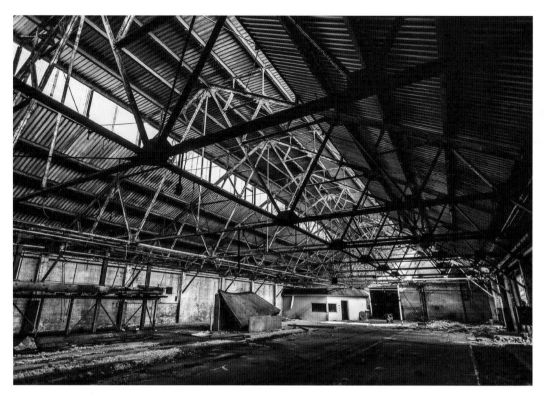

The oldest section of this building was built in 1916, with additional buildings being added to the complex over the years. The most recent addition was built in 1967. It's final tenant was Accurate Plating. (2014)

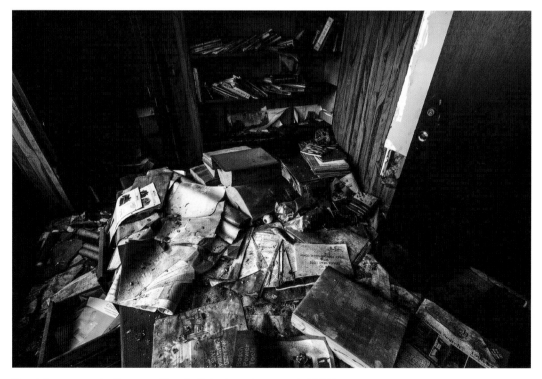

The plating company's offices were littered with books and paperwork. (2018)

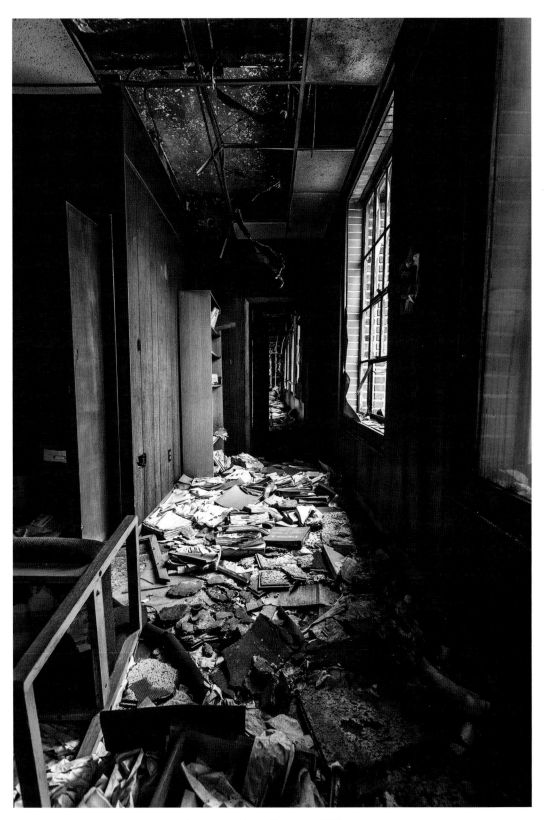

At some point there was a small fire in second-floor office area. (2018)

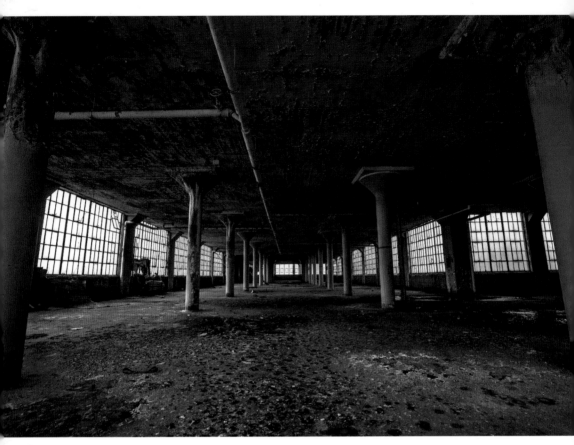

A 650,000-square-foot clothing factory built in 1917. A year after being built, the factory was briefly converted into a hospital for injured soldiers returning from WWI. (2018)

Opposite page: Although the layout of the Richman Brothers factory is fairly simple, it's sheer size and the number of stairwells can make the building a bit disorienting. (2018)

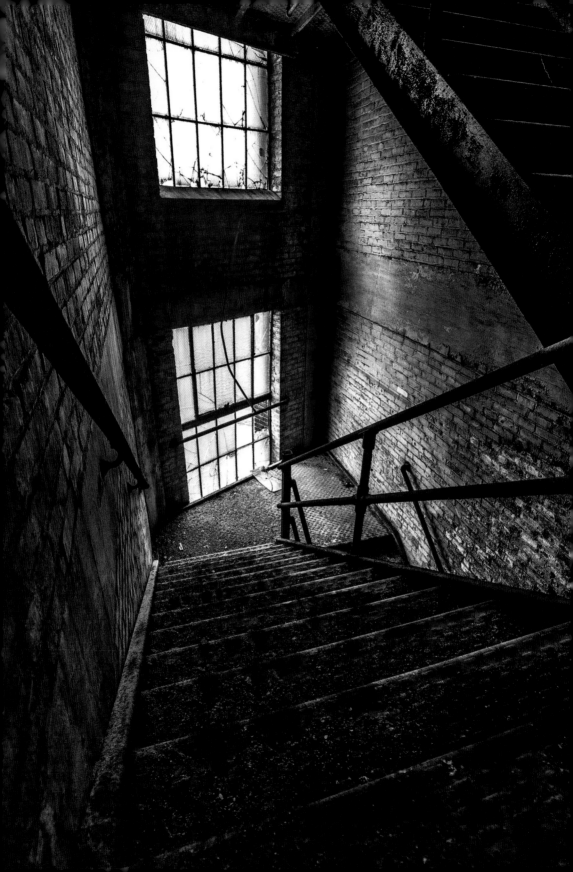

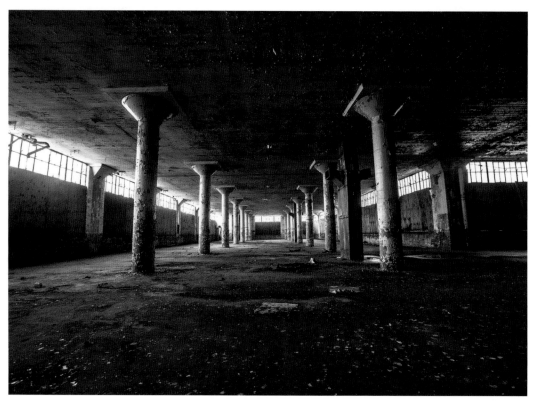

Painted mushroom columns in the front portion of the Richman Brothers building. (2018)

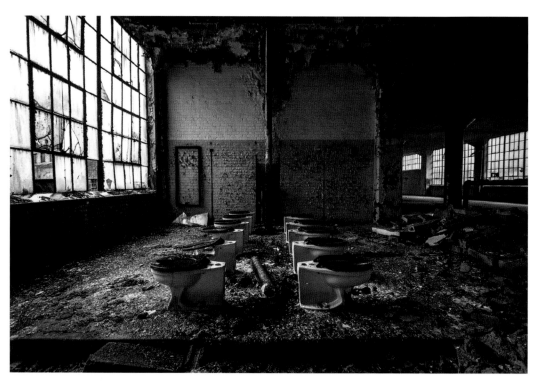

The restroom walls are all long gone, leaving the toilets looking out of place in the middle of a factory floor. (2018)

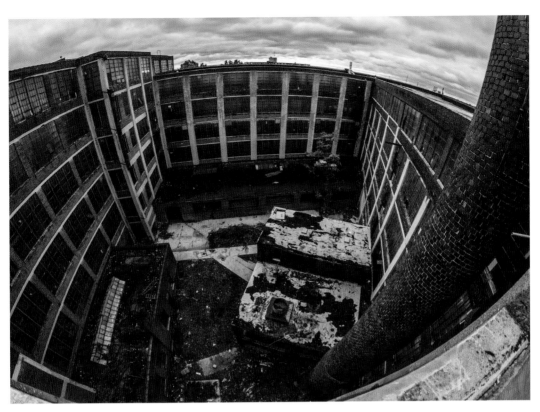

One of the large courtyards in the Richman Brothers building. (2014)

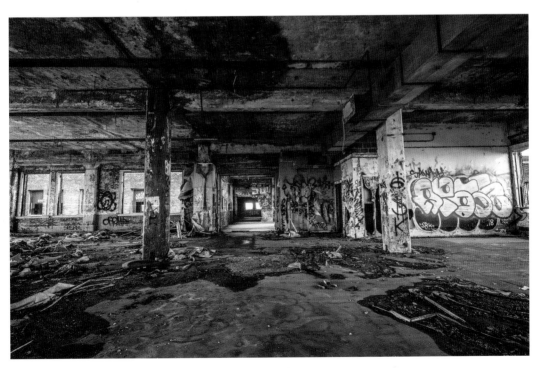

The Warner & Swasey Company was founded by Worcester Reed Warner and Ambrose Swasey in 1880. The company manufactured a variety of products but was best known for making telescopes. (2018)

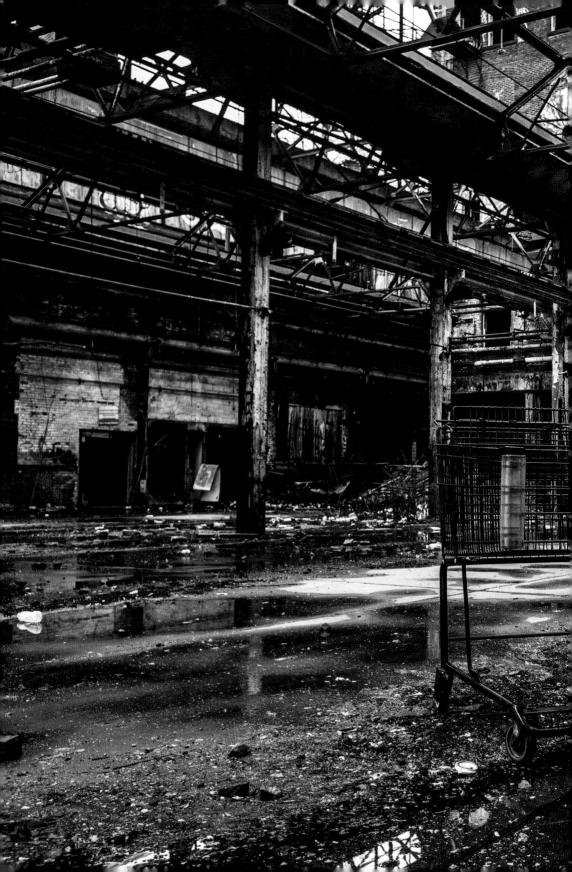

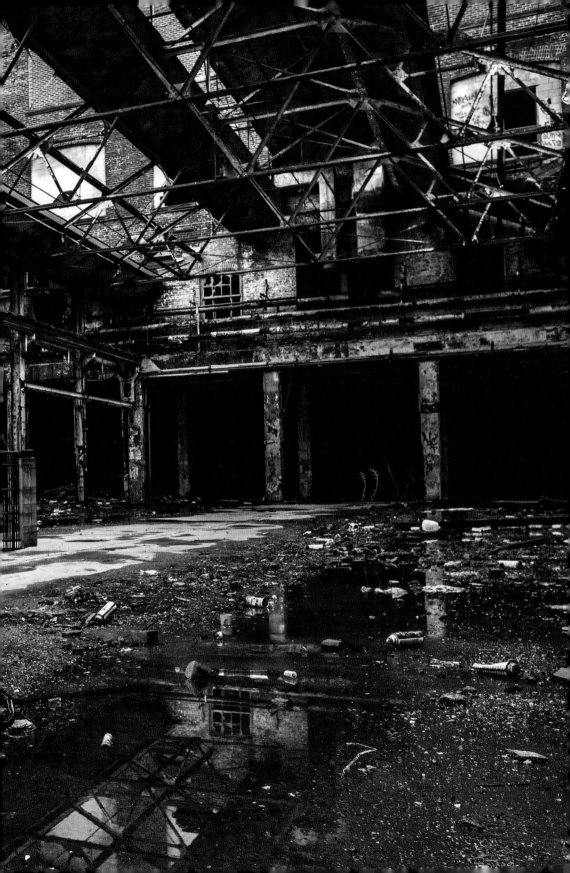

Previous page: The original Warner & Swasey building was built in 1880. It was replaced by this much larger building, with construction starting in 1904. During WWII, this room was filed with lathes where machinists made parts for ships, planes, and tanks. (2018)

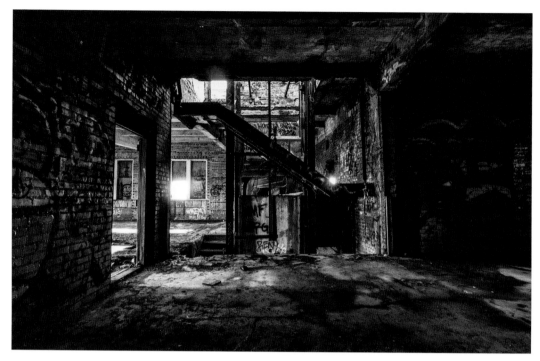

What's left of an elevator shaft and stairwell. (2018)

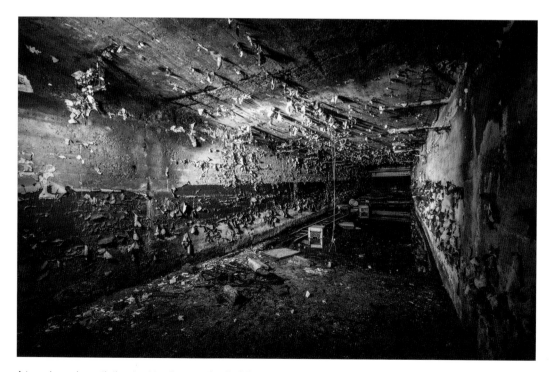

A tunnel runs beneath the street to where another building once stood. (2018)

2

EDUCATION

Cleveland has no shortage of abandoned school buildings. When the population declines, schools are often some of the first places to consolidate and close. They are large and expensive to maintain, and underfunded school districts often don't think twice about shuttering a costly property. While a handful of the city's old schools have been converted into apartments, plenty more wait patiently in the demolition line.

Schools can be some of the most fun types of places to explore. One of my favorites was Stanard School. The school was made up of two separate buildings connected by a tunnel. The original building was built in 1880 and designed by the same architect that designed the Arcade on Euclid Avenue. The second building was built in 1900 and was designed by William H. Dunn, the same architect behind St. Stanislaus in Slavic Village. The buildings had been empty for over thirty years by the time I first explored them. The first floor was almost entirely dark. Our cheap flashlights didn't offer much help. I had to throw my arm out and stop a friend from walking past me into one of the first classrooms we came upon. The floor was gone. It was just a huge black hole that fell into the basement. Looking up I could see that the second floor had collapsed as well—just one big hole cut straight through one of the most beautiful buildings I have ever had the pleasure to explore.

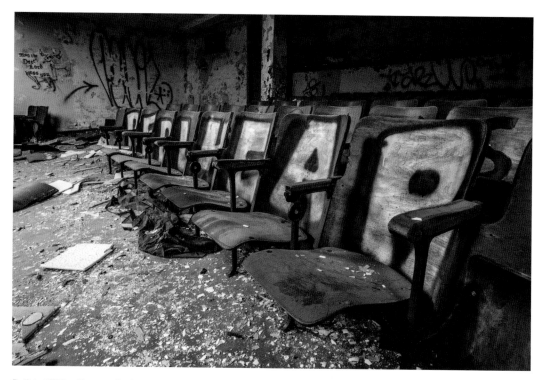

Built in 1903, with an auditorium and gymnasium being added in 1927. When the school was built E. 55th was known as Wilson Avenue, which is where the school gets its name. The school eventually closed in 2005. (2014)

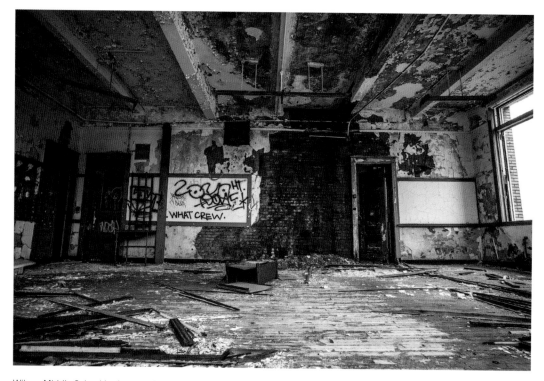

Wilson Middle School had some of the most brightly painted classrooms I've ever seen. Today much of the paint has peeled and been replaced by graffiti. (2014)

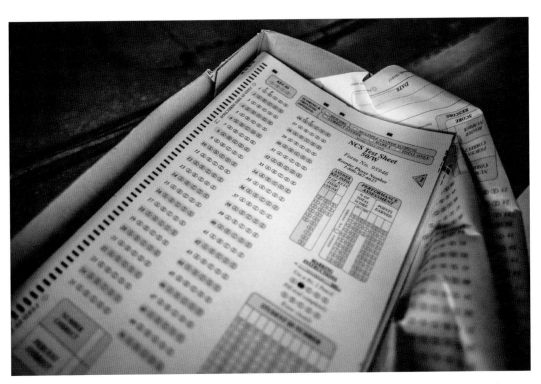

Test sheets on the floor of Wilson Middle School. (2014)

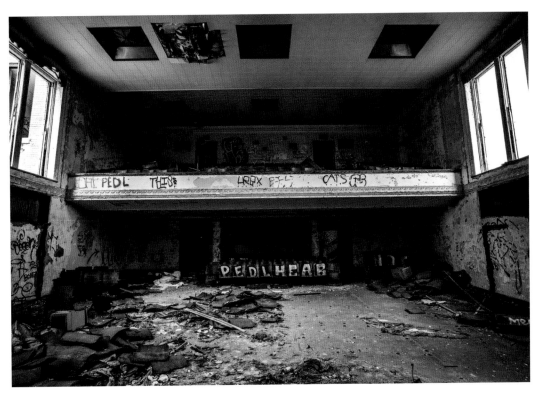

Most of the seats in the auditorium have been destroyed. (2014)

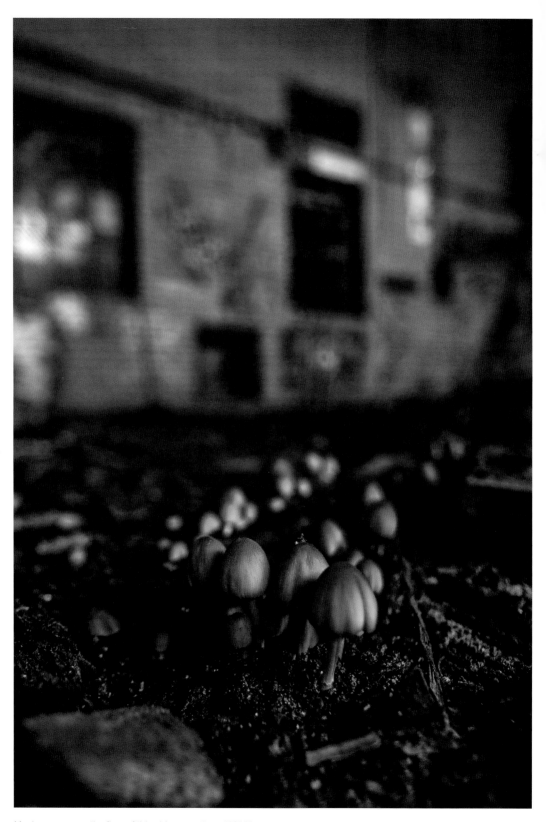

Mushrooms cover the floor of this old gymnasium. (2018)

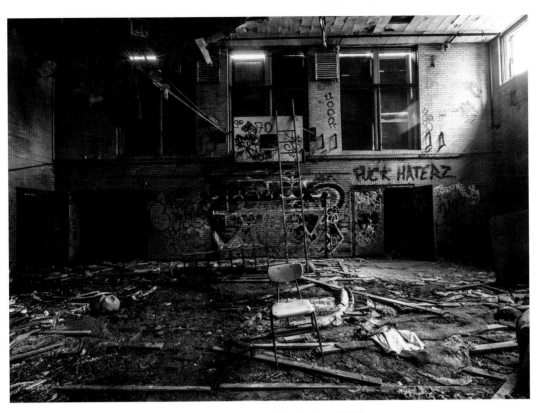

The school's gym, almost unrecognizable after years of deterioration. (2018)

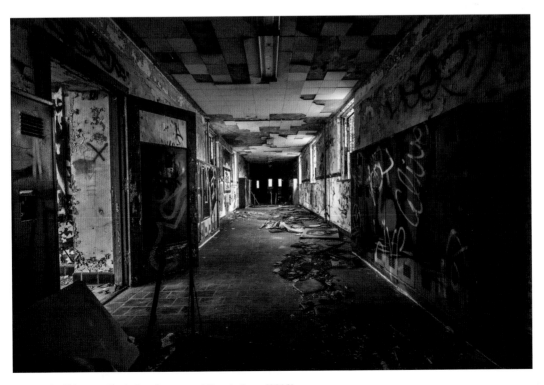

Graffiti covers the lockers in a second-floor hallway. (2018)

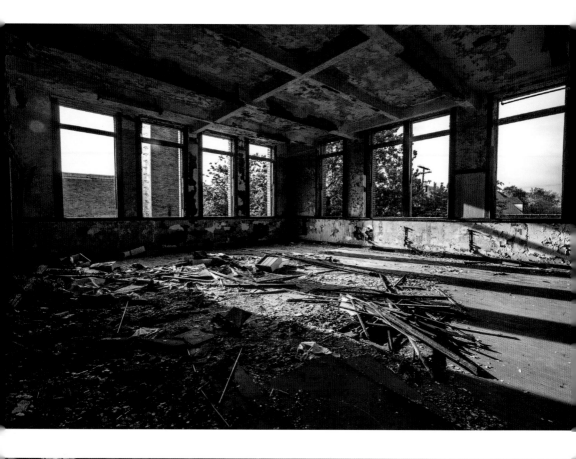
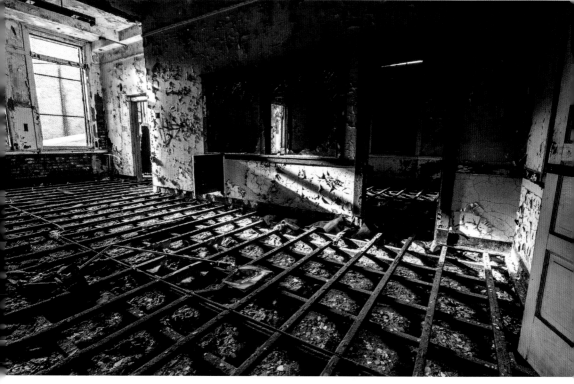

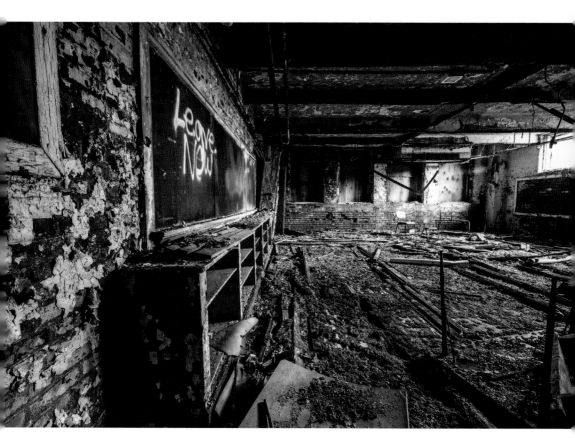

This school had a dozen or so classrooms in the basement. These rooms have the least graffiti, but the most decay. (2018)

Opposite above: A large classroom left open to the elements. (2018)

Opposite below: Some areas of this school have had the flooring removed. (2018)

Next page: This observatory was built between 1918 and 1920 for Case Western University. It was constructed as a gift to the School of Applied Science by Cleveland telescope manufacturers Worcester Warner and Ambrose Swasey. (2014)

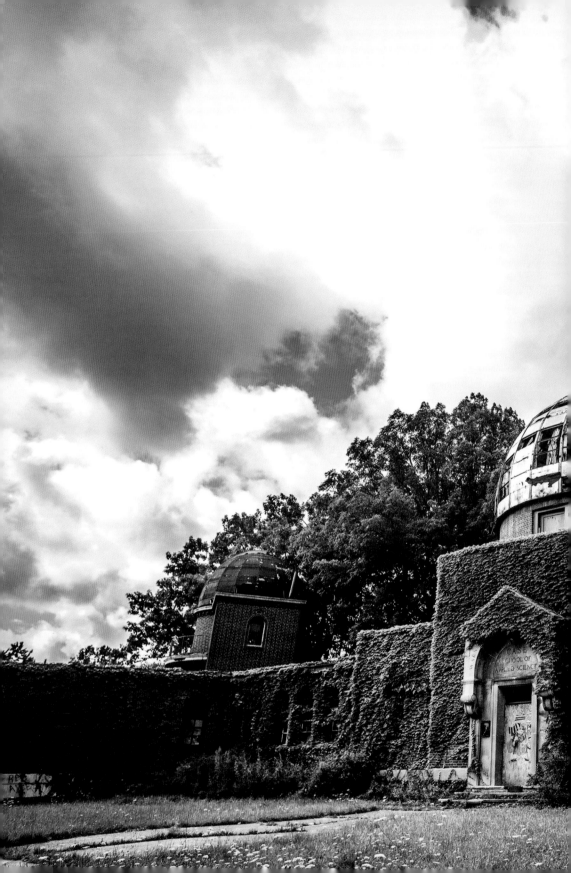

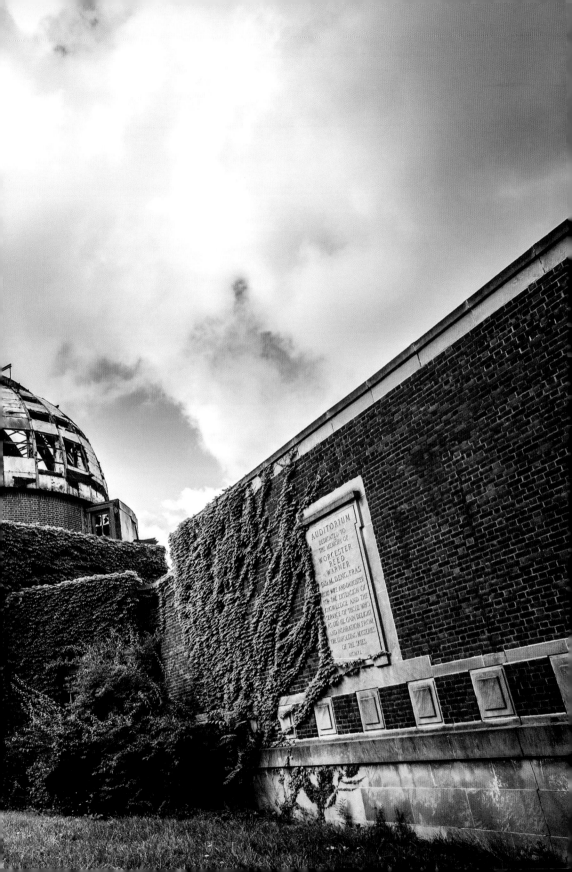

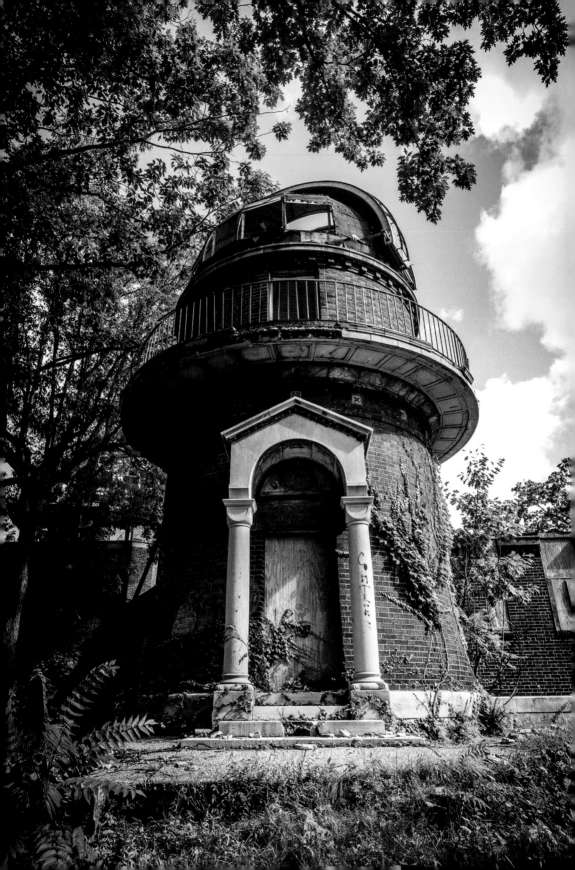

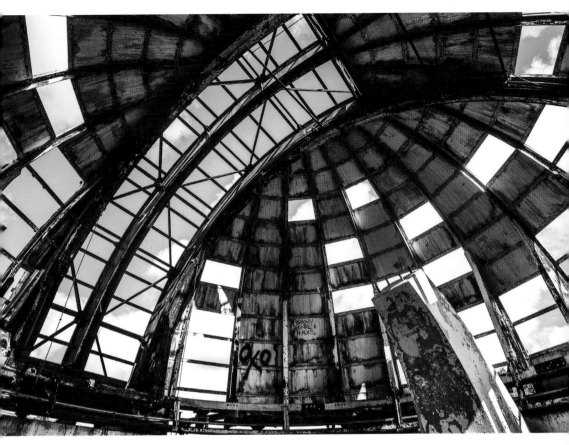

Due largely in part to light pollution, the observatory was eventually closed and the remaining Case Western faculty were transferred to the main campus by 1982. (2014)

Opposite page: In 1940, a new wing was added, which included a library and a second telescope. (2014)

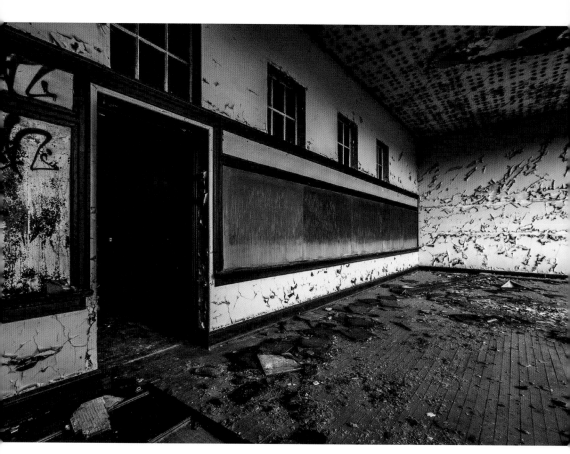

This school was built in 1913. (2018)

Opposite above: In the mid-1920s, this small school had roughly 1,000 students. (2018)

Opposite below: One of the more interesting elements of this school building were the large skylights on the top floor. (2018)

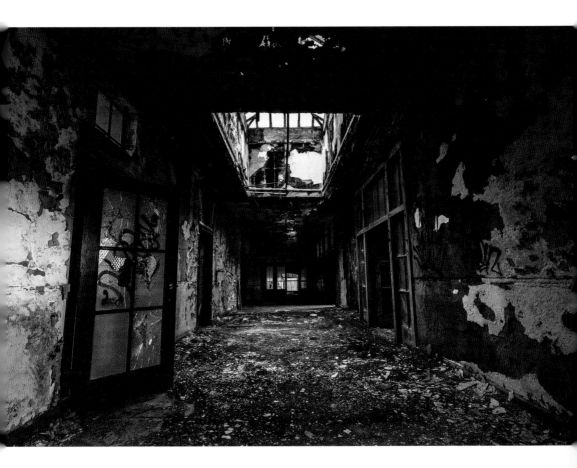

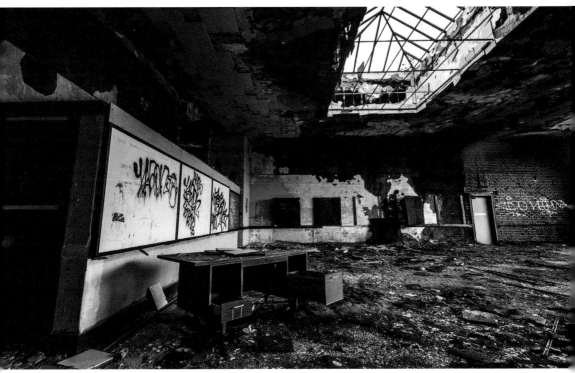

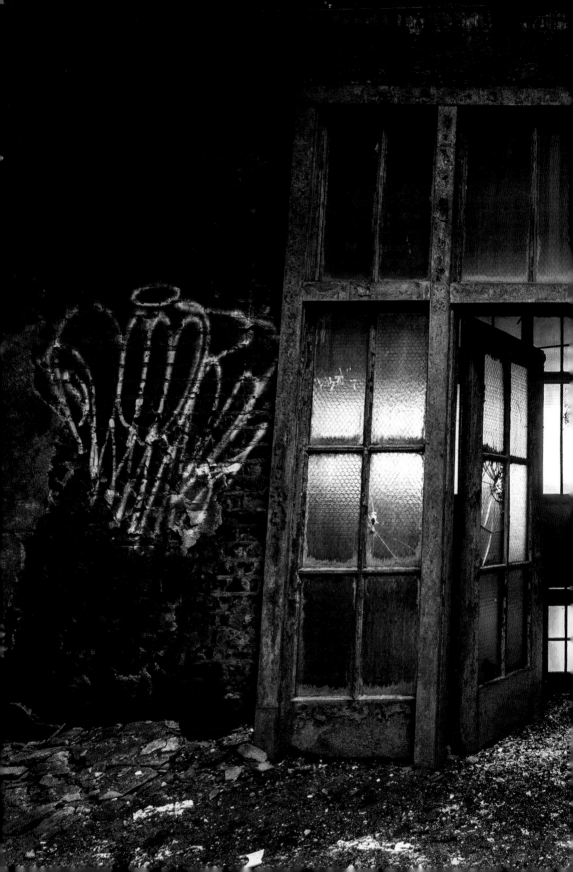

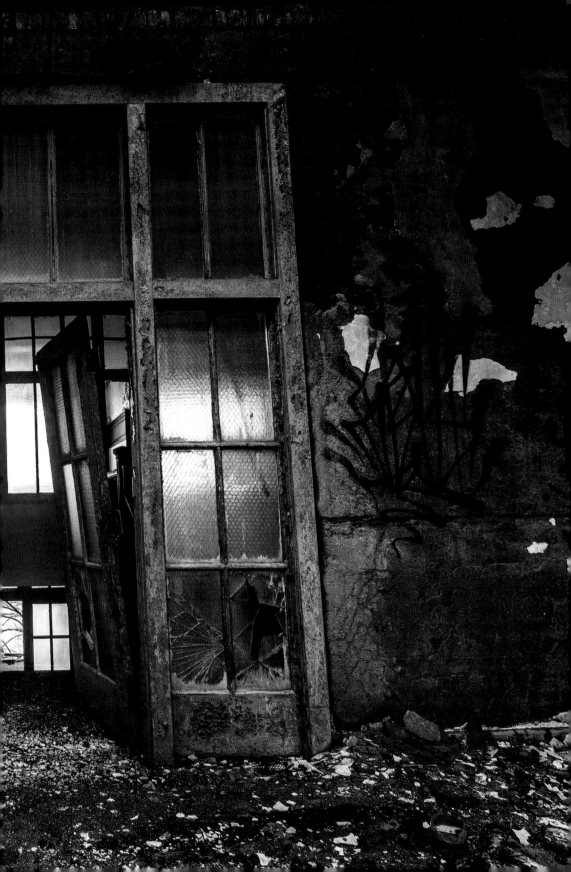

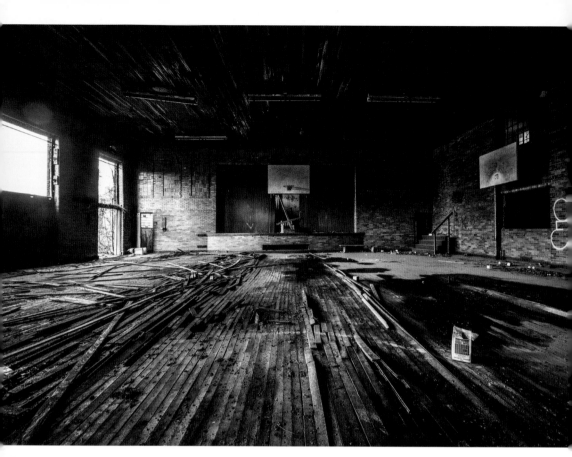

Above: Rotten floorboards in a gym. (2018)

Previous page: Deteriorating walls flank the entrance to the main stairwell. (2018)

3

RESIDENTIAL

There is something particularly unsettling about abandoned houses and apartments. The setting is so familiar to our own places of refuge that we call home. It is difficult to imagine these spaces where we feel safe and relaxed, ever being so neglected. A house that once protected a loving family now sits ignored and in ruins. It is easy to walk through these places and almost see the ghosts of what once was. You can't help but feel sorry for these homes.

What is always shocking is seeing what has been left behind. While some homes are completely empty, others have everything left behind, right down to food in the cabinets. Clothes, photographs, family mementos—items that most of us would never think of leaving behind no matter how rushed our departure. That is what makes these places the most fascinating. You can catch small glimpses into the lives of those that used to live there.

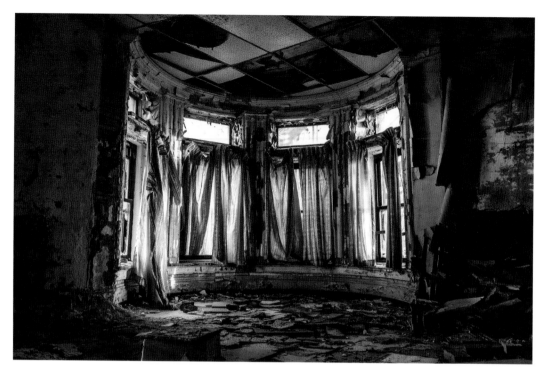

Levi Scofield was one of the most prominent architects in the state. He designed such buildings as the Ohio State Reformatory in Mansfield, and the Ohio Lunatic Asylum in Athens, Ohio. His abandoned mansion sits on a hill overlooking the city. (2015)

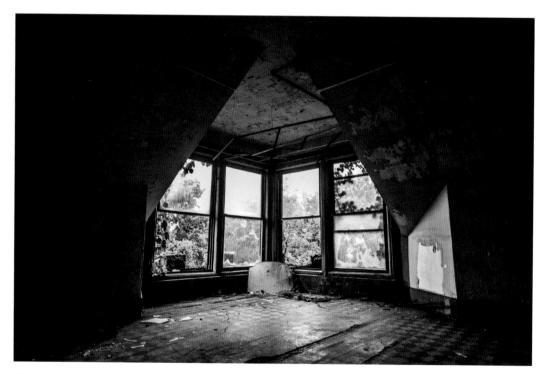

The Schofield Building at the intersection of E. 9th and Euclid Avenue was another one of Levi's designs and where his architectural firm had its offices. It was recently restored and hosts a hotel of his namesake. (2015)

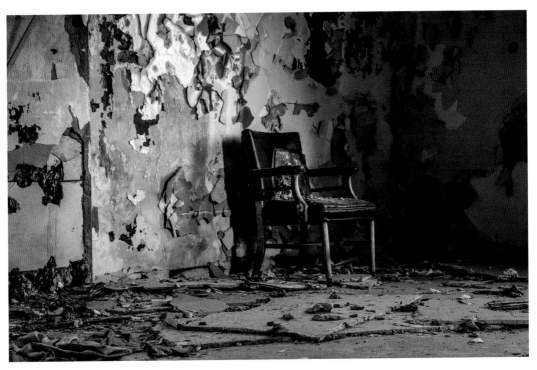

Levi Scofield also designed the Soldiers and Sailors Monument in Public Square. (2015)

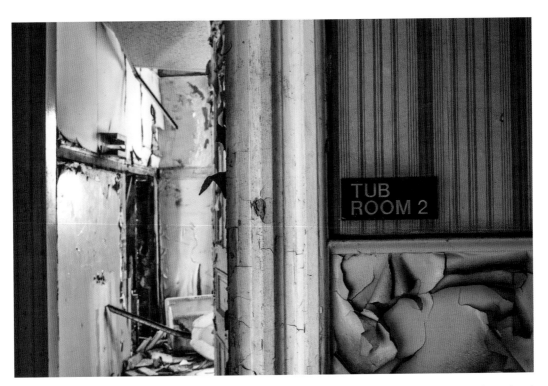

In 1925, the Scofield family sold the mansion to the Cleveland Catholic Diocese. For thirty years it served as a chapel and convent. In 1955, it was sold and converted into a nursing home. (2015)

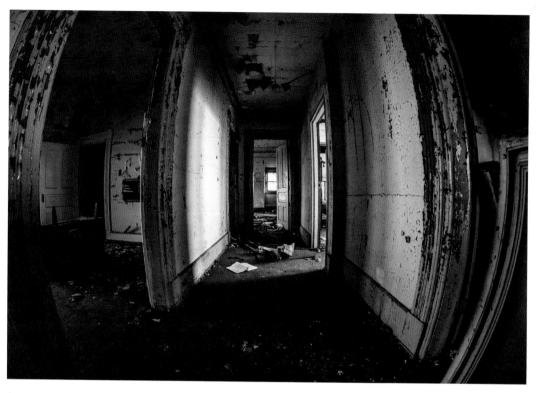

An upstairs hallway inside of Levi Scofield's former residence. (2015)

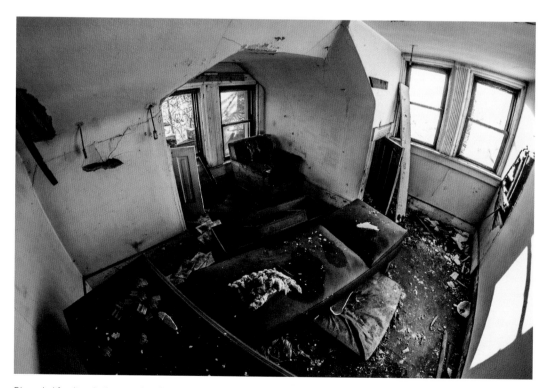

Discarded furniture in the mansion. One of the walls here is covered in writing. I'm not sure if this was written by a former resident of the nursing home, or perhaps by someone who at some point lived in the abandoned structure. (2015)

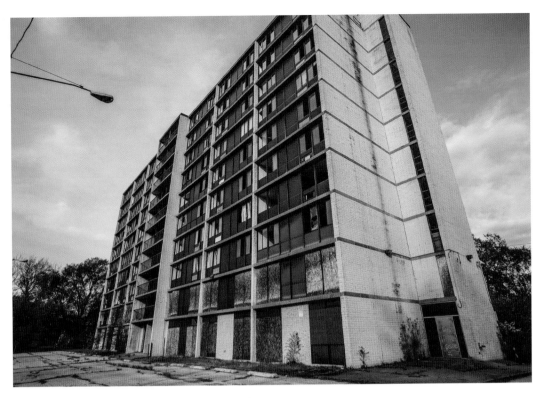

A 116-unit apartment complex built in 1973. (2014)

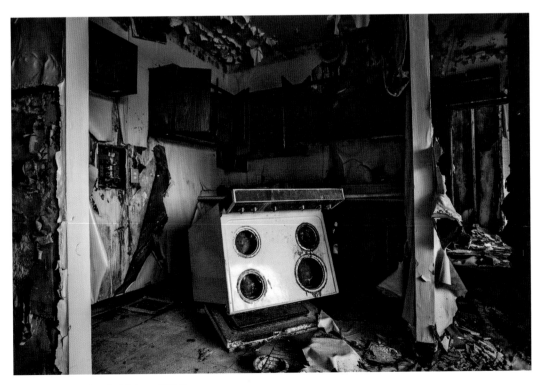

The remains of a kitchen. (2014)

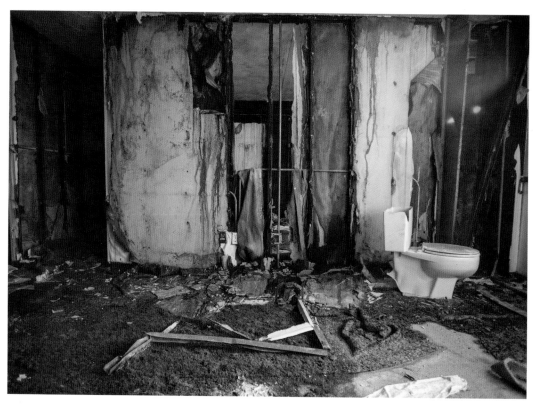

A thick layer of moss covers the living room floor. (2014)

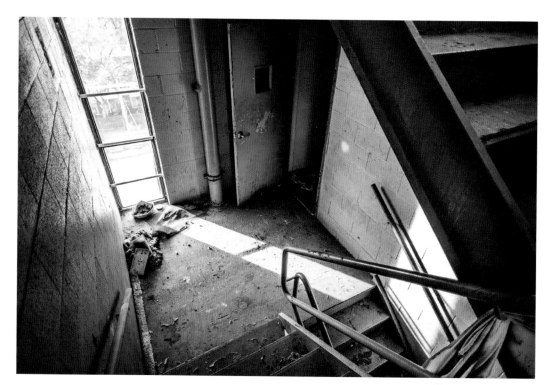

One of the stairwells inside of the massive apartment complex. (2014)

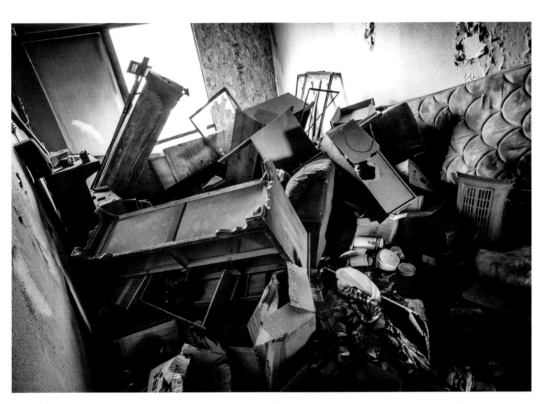

Most of the apartments here were completely empty; however, a small number of them were full of furniture and household items. (2014)

Next page: This apartment building, built in 1904, at one point had another section attached to it, but according to a police officer that we spoke with, it had collapsed a few years back. (2014)

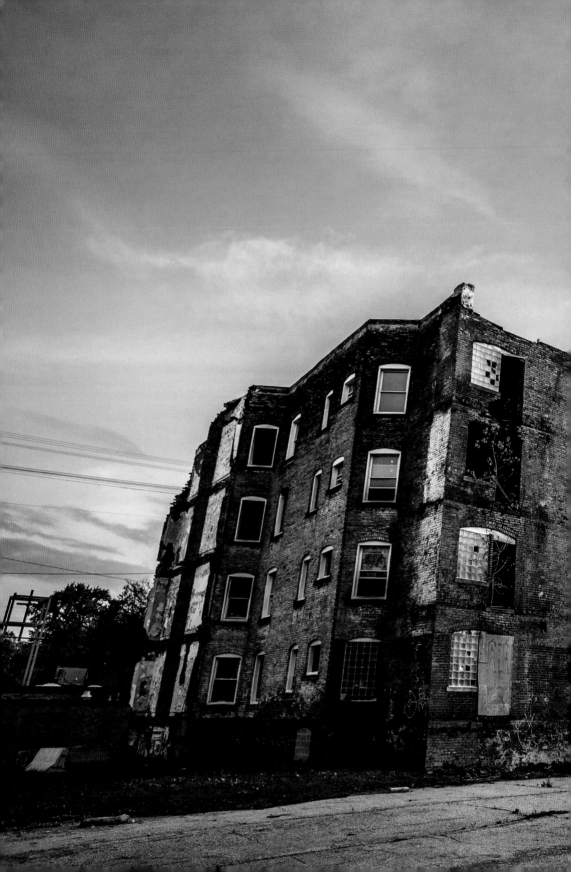

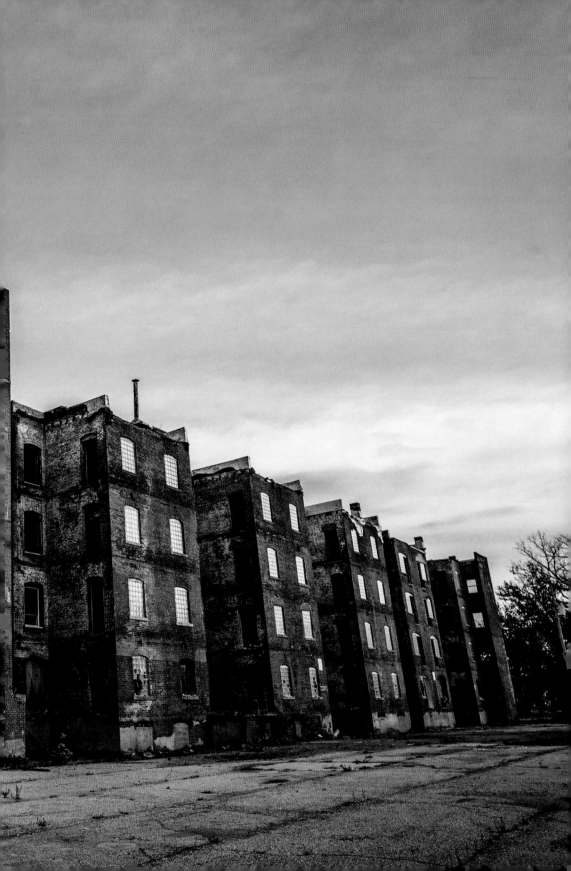

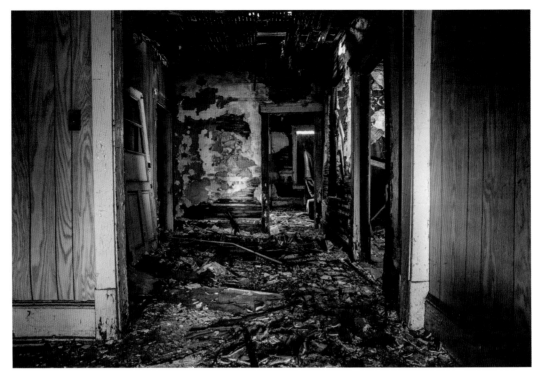

A leak in the roof of this apartment building has led to a series of holes that have rotted through every floor of this building. (2014)

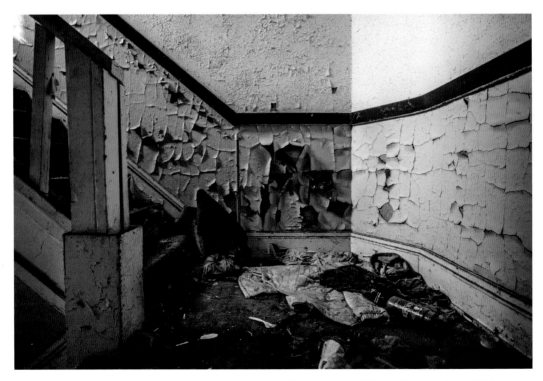

Clothes and garbage at the base of a stairwell. This apartment building was built in 1900 and foreclosed on in 2013. (2014)

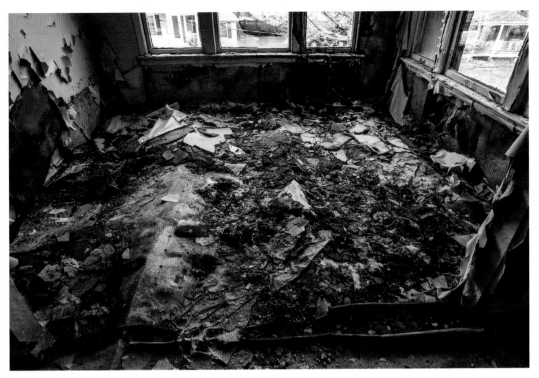

Decaying ceiling tiles and moss gives the illusion of carpet on what was once a linoleum floor. (2014)

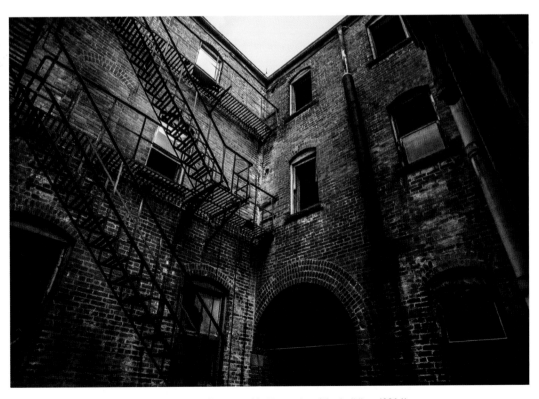

This old apartment building had a small courtyard in the center of the building. (2014)

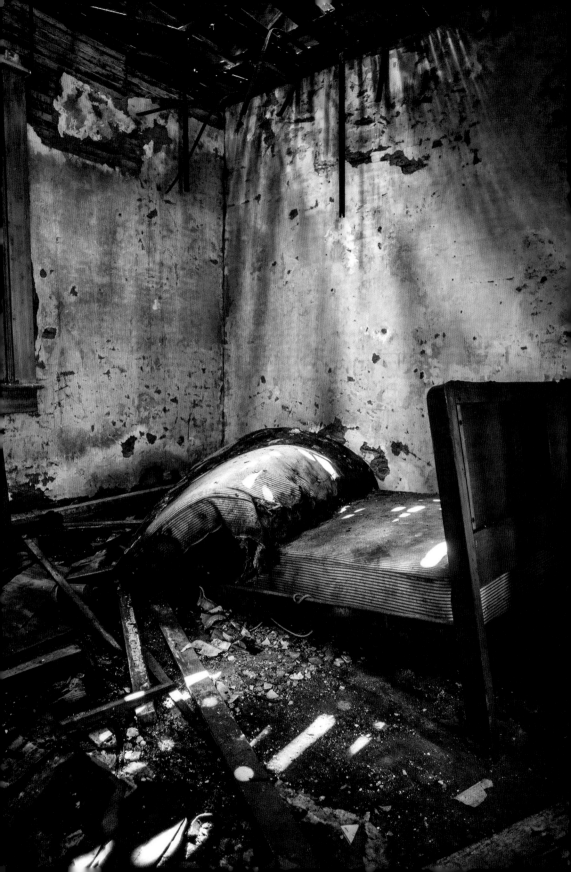

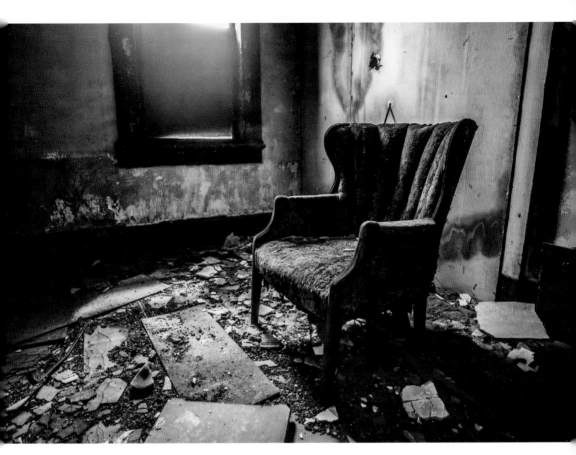

A lone chair sits in the rubble that was once a bedroom. (2014)

Opposite page: Light shines through holes in the roof onto a bed that has rotted into two. (2014)

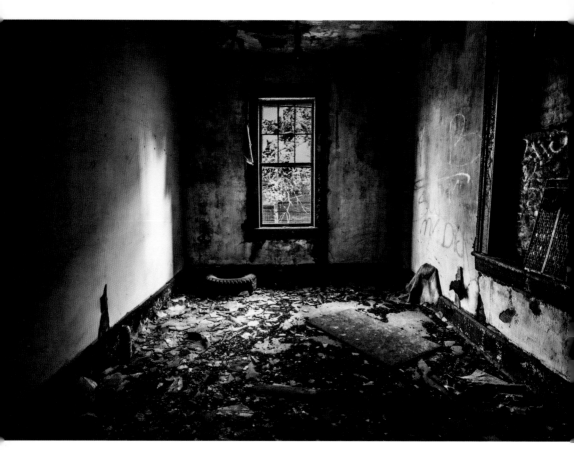

All of the rooms in this apartment building were incredibly small. The idea of living in such a cramped space is probably panic inducing for a lot of people, but this used to be someone's cherished home. (2014)

Opposite above: The top floor of this apartment building was one large open room, with nothing but a desk remaining. (2014)

Opposite below: The decay in apartments and houses is always so much more dramatic than the deterioration of old factory buildings that are built mostly of brick, steel, and concrete. (2014)

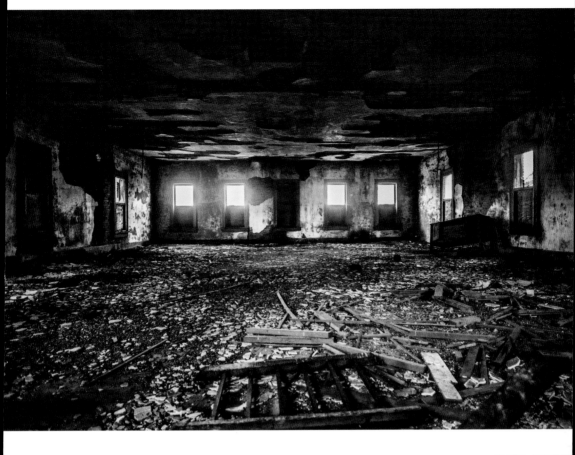

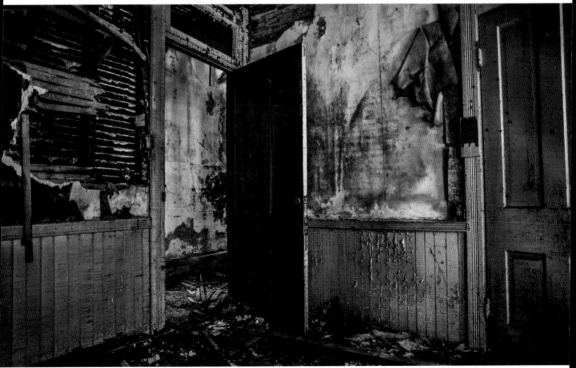

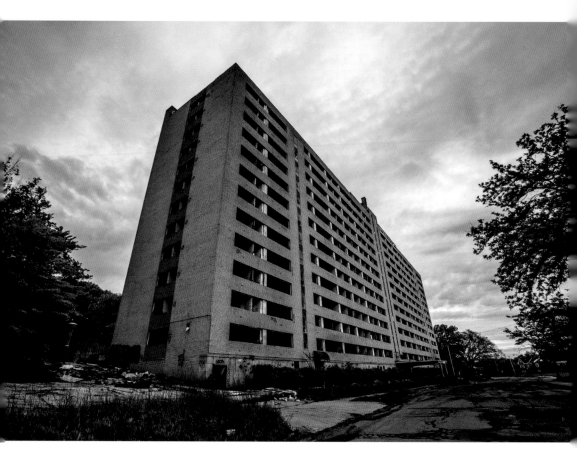

This 254-unit apartment complex was built in 1961 and has only been vacant since the latter half of 2014. (2018)

4

COMMERCIAL

There are all sorts of different types of commercial buildings sitting vacant in the city of Cleveland: hotels, stores, movie theaters, restaurants, and more. One of the best was the old Howard Johnson Motor Inn on the Shoreway. It was a twelve-story hotel built in 1965. It was designed in a way that gave every room a view of Lake Erie. The rooms that faced west also offered incredible views of downtown. I remember nights sitting on the roof of that hotel watching the traffic zoom past on Interstate 90. The old building was eventually taken down in 2009.

Another great commercial building that no longer exists is the Cleveland Cold Storage building. It was demolished in 2012 to make way for the George V. Voinonich Bridges. This nine-story windowless building sat just across the river from downtown, and was topped off with a water tower. The views from that roof were unbeatable. Navigating the pitch-black building in order to access the roof was part of the fun. Locked doors, and completely rotted out stairwells meant you had to take one set of stairs up a few flights, then take another set of stairs down a floor, only to use a third set of stairs to continue upward. It took us a few tries before we finally figured out the correct combination.

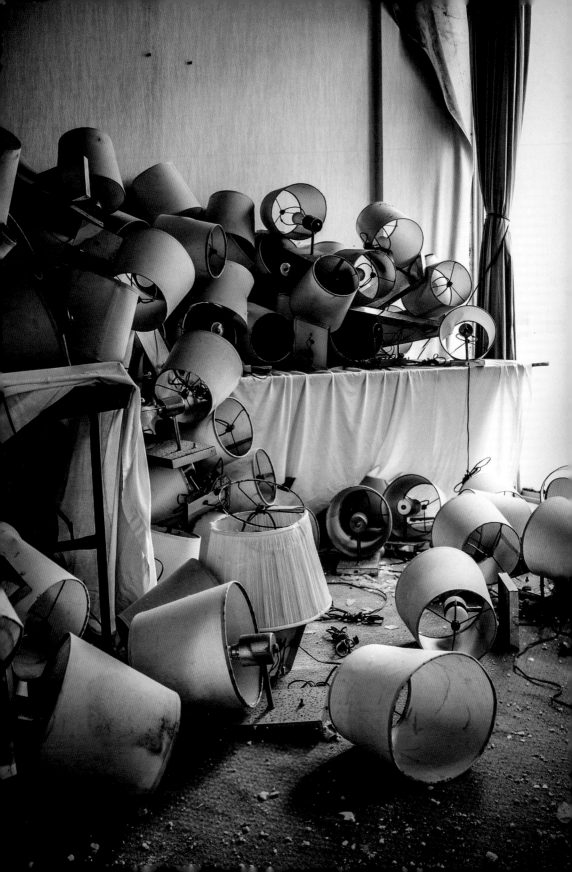

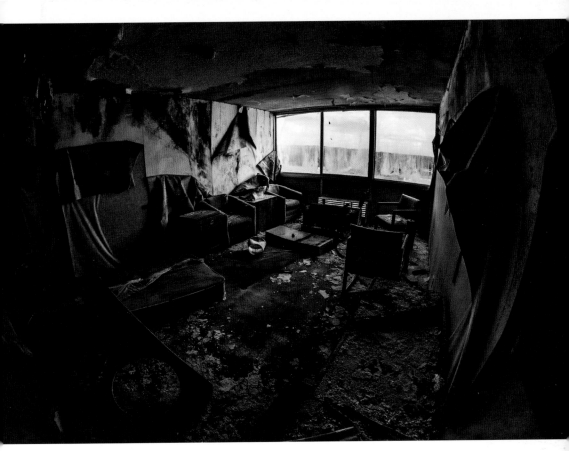

Some of the upper floors in this hotel were left just as they were the day the hotel closed, while the lower floors seemed to have been emptied, and most of their contents sold off. (2013)

Opposite page: A room full of lamps in an old hotel. There were also rooms full of framed prints, mattresses, chairs, and any other items you might find in a hotel room. With each different type of item having its own dedicated room. (2010)

Next page: The Meyer's Dairy building was torn down in 2014. One of its unique features was the multicolored windowpanes. (2010)

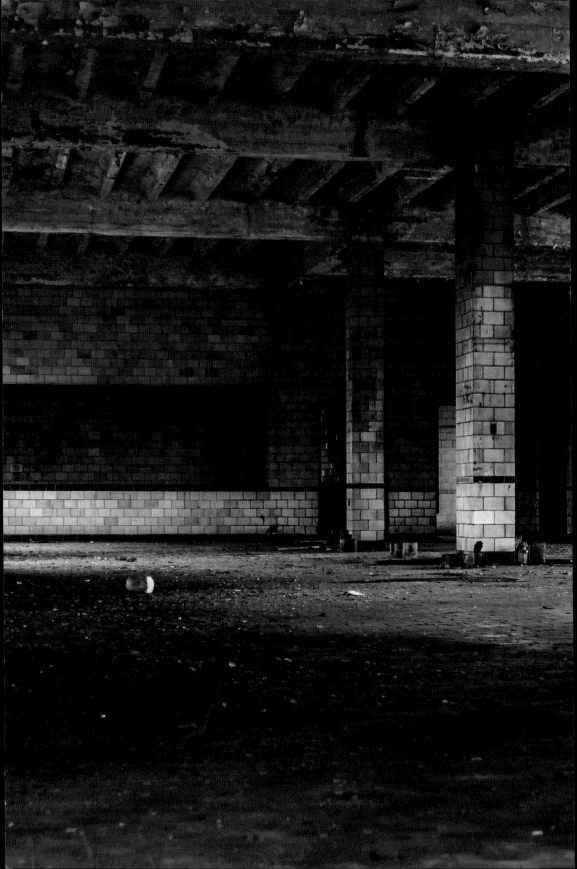

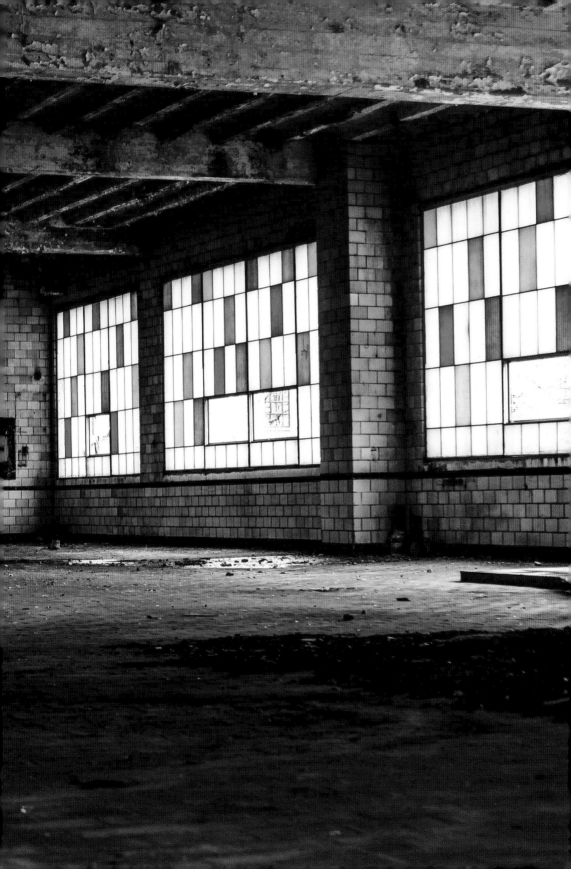

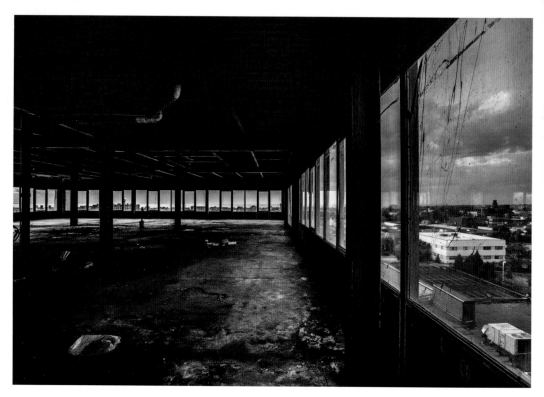

An eight-story office tower constructed in 1959. The first few times that I explored this building, there were walls separating the various offices and conference rooms. These walls were all taken down during an asbestos abatement. (2018)

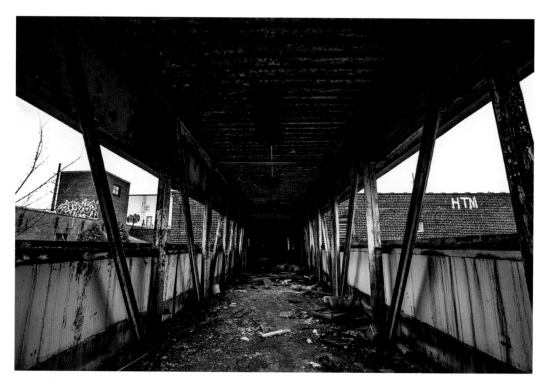

The building was originally built by Star Bakery Company in 1916. In 1941, Hough Bakery purchased the building. (2018)

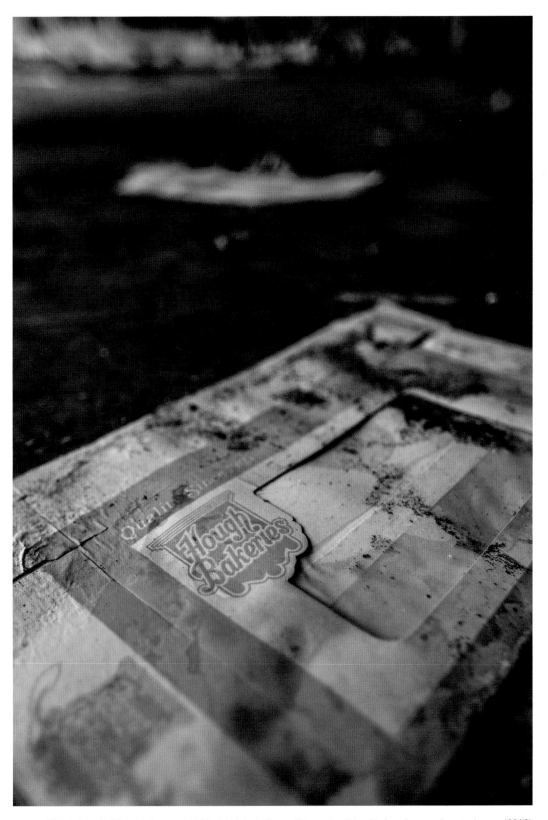

This bakery building had so much left behind, including pallets and pallets of bakery bags and pastry boxes. (2018)

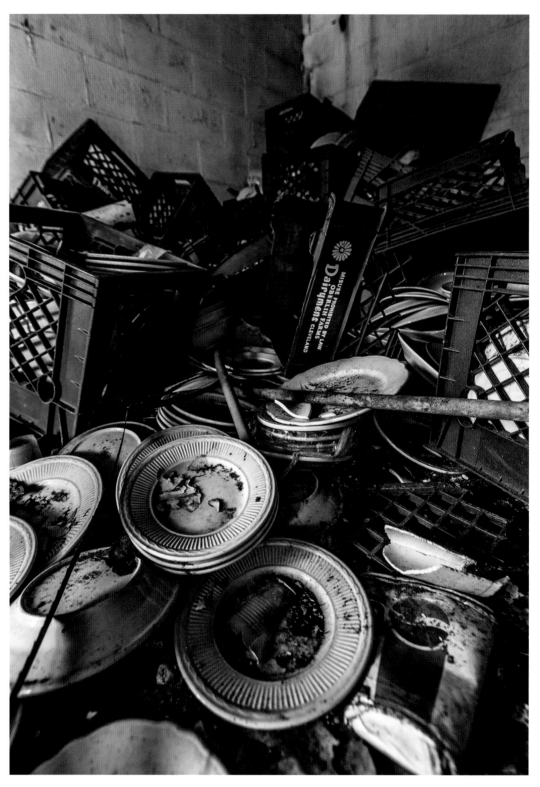

Hough Bakery was well known and much loved throughout the area. Unfortunately, due to lack of modernization and increasing competition, the bakery was forced to abruptly close in 1992. (2018)

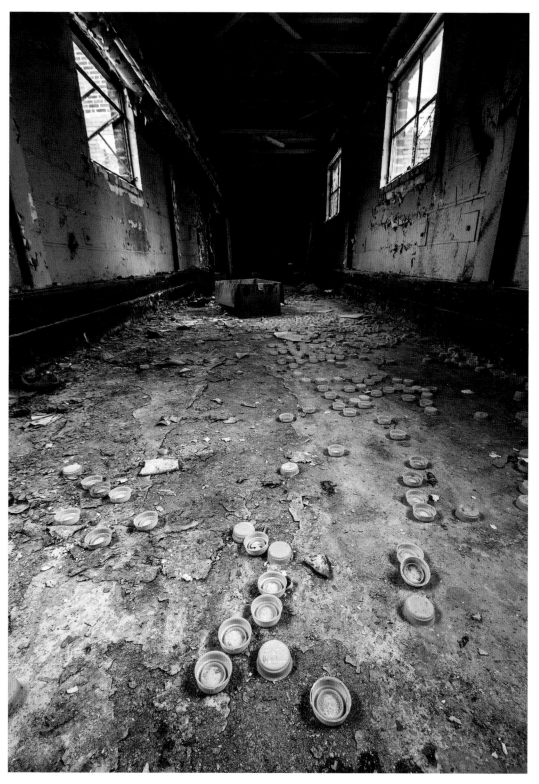

Yellow bottle caps scattered across a walkway between two buildings. (2018)

Next page: An old conveyer oven is one of the only remaining pieces of equipment from its days as a bakery. (2018)

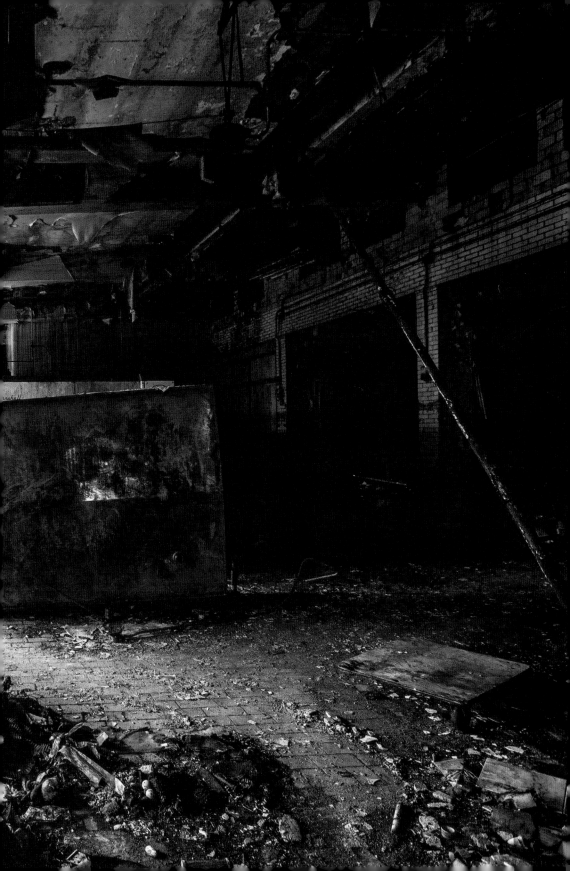

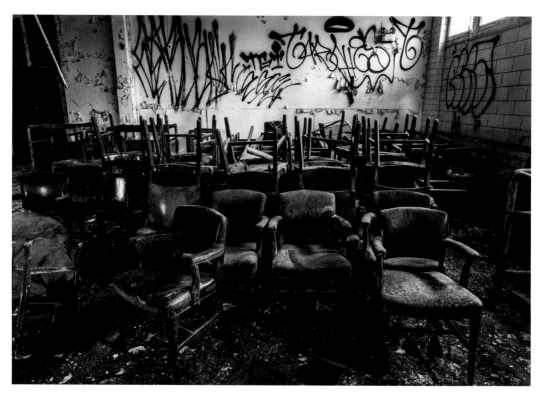

Stacks of chairs in a room that smelled like some sort of rancid chemical. (2018)

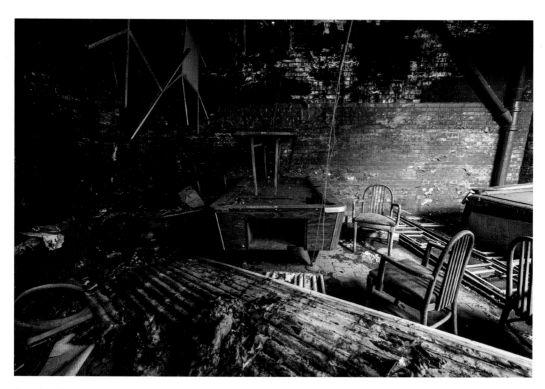

A section of the bakery was converted into a club. There were multiple pool tables, a jukebox, and a fake palm tree. This section of the building seemed to be the most damaged. (2018)

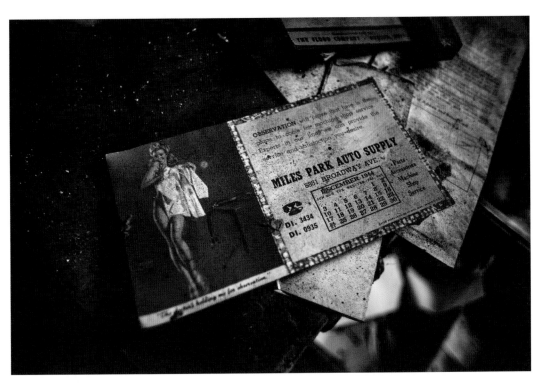

A calendar from 1944 sits on a desk at an auto parts supply store. This building sat vacant for years before finally being razed in 2015. (2014)

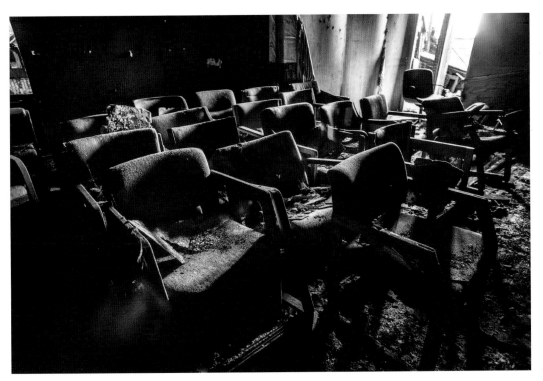

These buildings on the city's east side hosted several different businesses. The main building was at one point a laundry service, while the back portion of the complex held a stereo store. (2014)

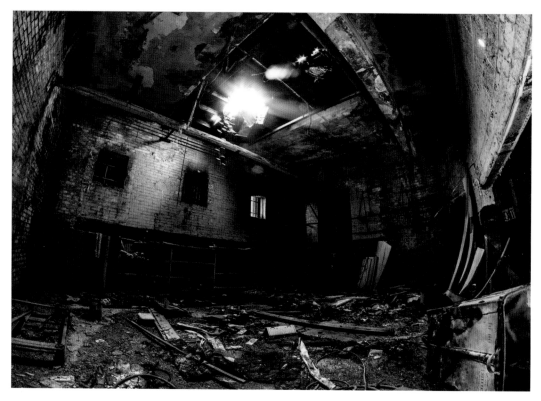

This section of the building is the area that once housed a stereo store. (2014)

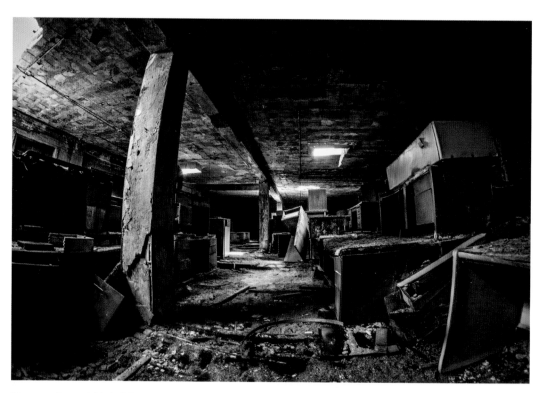

The upper floors of this building were entirely full of desks and chairs. (2014)

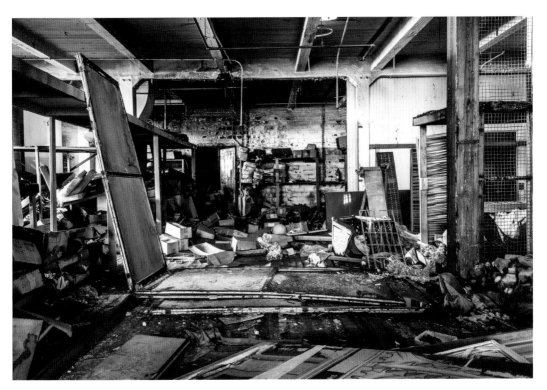

Mutual Display was in business for almost eighty years. They provided window displays for department stores as well as party decorations and movie props. The business closed in 2009. (2015)

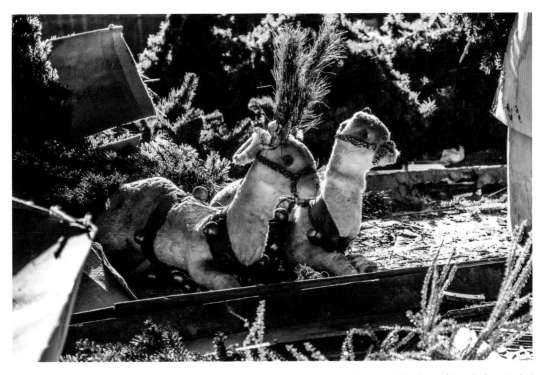

This building was full of various holiday decorations. Each floor was a different holiday. It was fun to look around at all the things left behind. (2015)

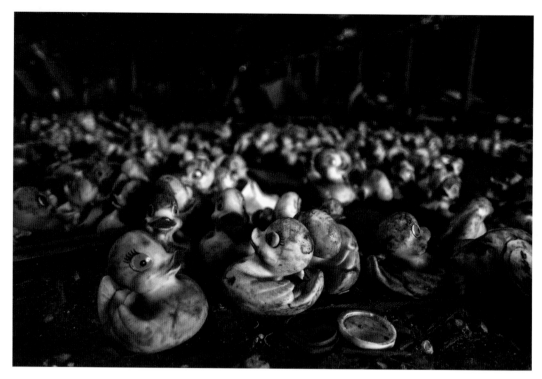

This building served multiple uses over the years. Most recently it was used by a plumbing and supply company; however, it started as a garage for the city's streetcars. Although, it is most famous for its rubber ducks. There were hundreds, if not thousands of rubber ducks. The building was destroyed by fire in 2014, but thankfully most of the ducks seem to have made it out and have since moved to other abandoned buildings around the city. (2013)

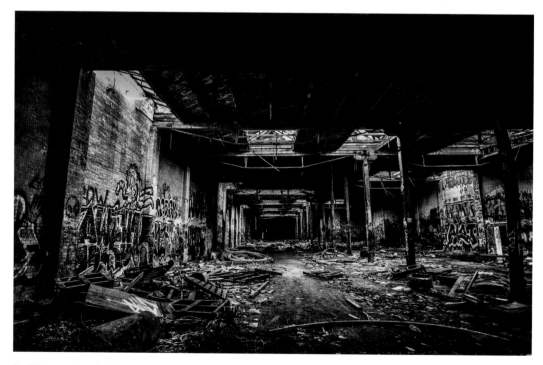

Graffiti covered much of the interior. This photo was taken one week before the building burned. (2015)

5

WORSHIP

When Cleveland's population was at its peak, nearly every neighborhood had at least one church, sometimes several. Today plenty of these houses of worship have been torn down or abandoned. The architecture is something no modern church will ever duplicate: high vaulted ceilings, frescoes, hand carved wood paneling, ornate plaster work, and of course stained-glass windows. Not to mention beautiful old pipe organs which are all too often quickly dismantled and sold for scrap by metal thieves. These places are truly awe inspiring.

What is most shocking is how a structure that was built to honor God can be so quickly forgotten. It is easy to wonder why and how anyone could turn their backs on these places. The truth is that they have no choice. These buildings are supported by the weekly offerings from those who attend. When the neighborhood starts to crumble, and the few remaining residents do not have anything to give, the doors have no other option but to close. While witnessing the decay inside of such a beautiful building is thrilling as a photographer, I am sure that those first parishioners would be heartbroken to see the state of their beloved churches.

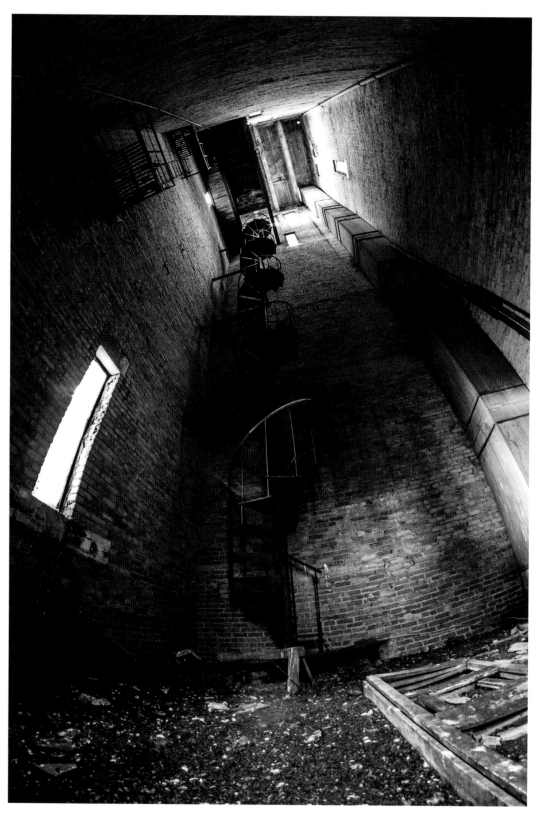

This bell tower is all that remains of St. Agnes, which was destroyed by fire in 1974. (2014)

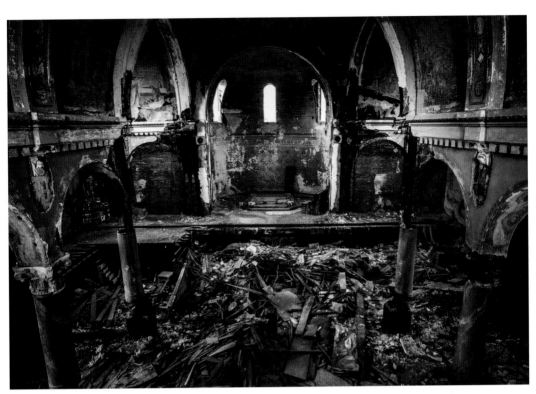

St. Joseph Byzantine was built in 1913. It was rebuilt in 1933 and then closed in 2002. It was one of the first ornate old church buildings that I ever explored. I still remember being awe struck the first time I walked in. (2014)

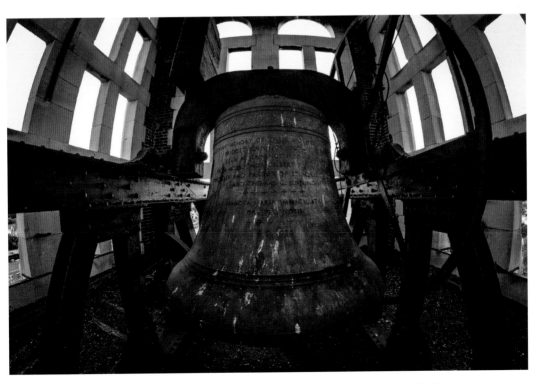

Watching the sunrise from this hundred-year-old bell tower is an incredible experience. (2014)

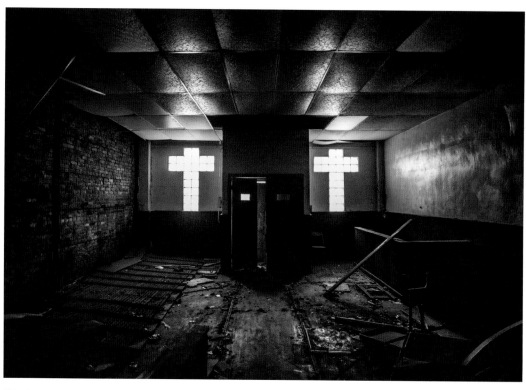

This tiny storefront church was demolished shortly after my first and only trip here. (2014)

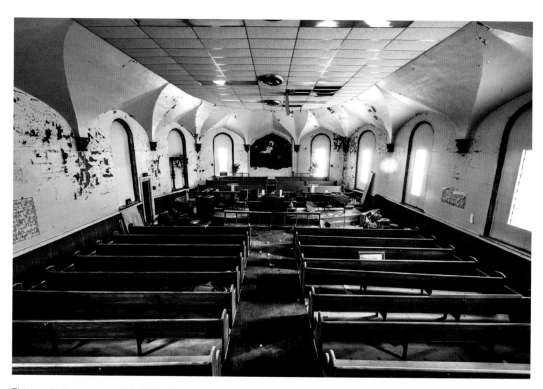

This small church was built in 1903. The building had the narrowest spiral staircases I'd ever seen. Each stair was about the size of a pizza slice. (2018)

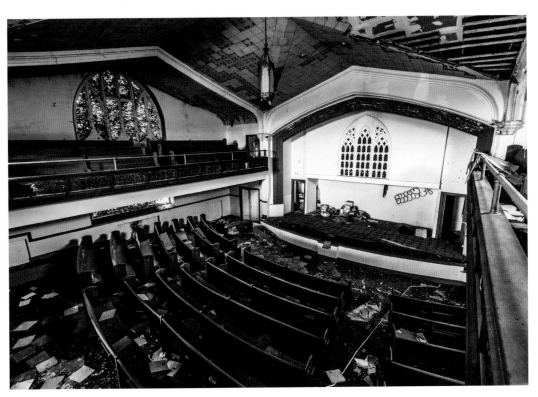

This church was built in 1919 and also operated a small school. (2018)

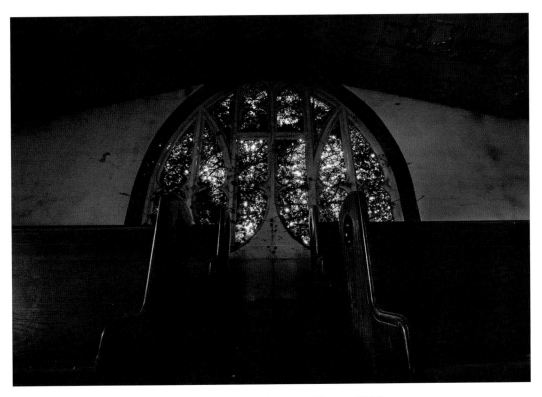

Most of the original stained glass is gone, but nature has created its own. (2018)

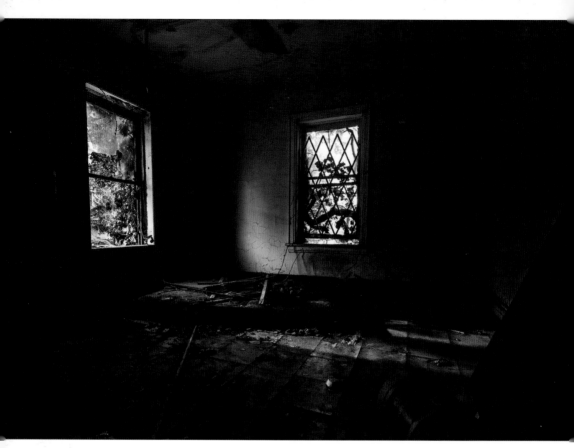

Morning light beams into a room, falling onto a discarded mattress. (2018)

Opposite page: This small neighborhood church was built in 1891. (2018)

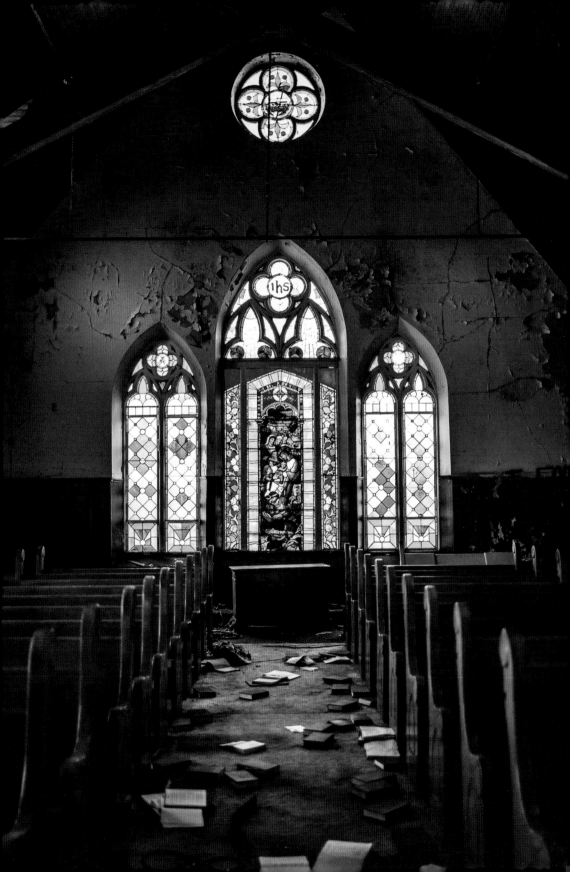

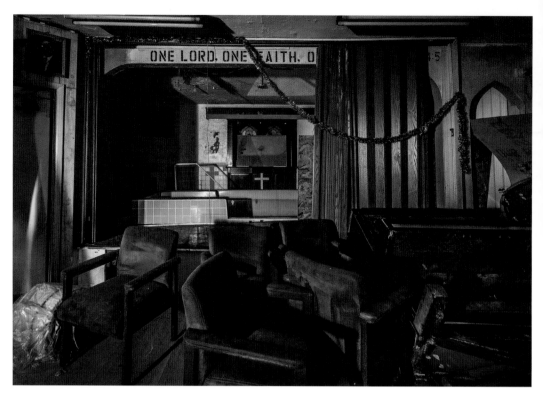

A basement baptismal pool. (2018)

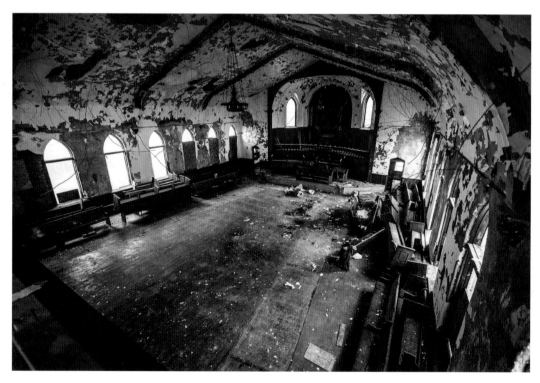

On my first visit to this church, there was a hideous drop ceiling that made the place look like someone's basement rec room. When I returned two years later, the drop ceiling had been taken down to reveal it's true architecture. (2018)

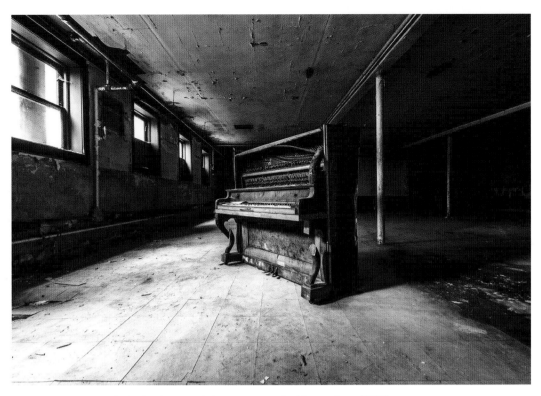

The basement of this church was entirely empty except for this one piano. (2018)

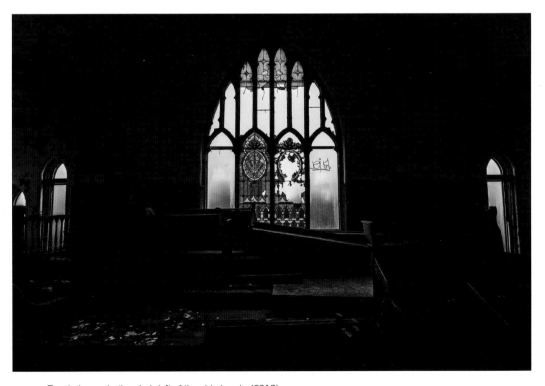

Toppled pews in the choir loft of the old church. (2018)

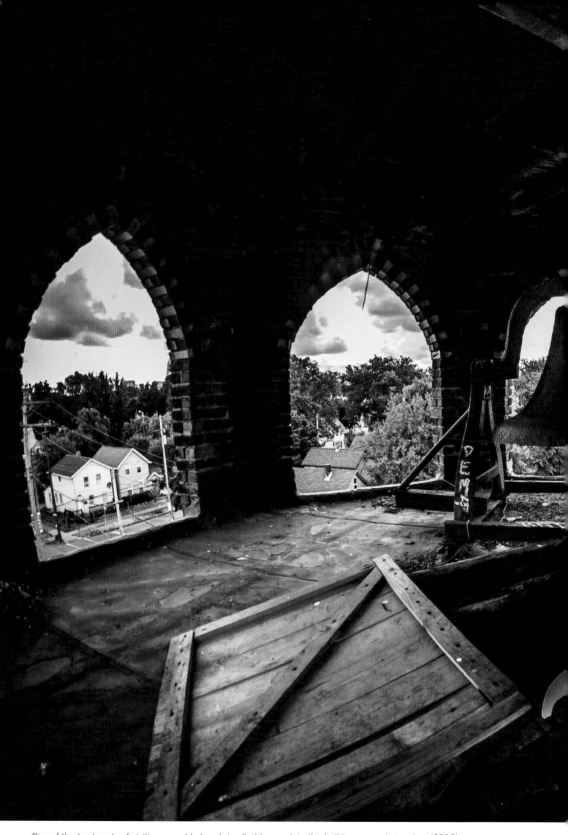

One of the best parts of visiting any old church is climbing up into the bell towers and steeples. (2016)

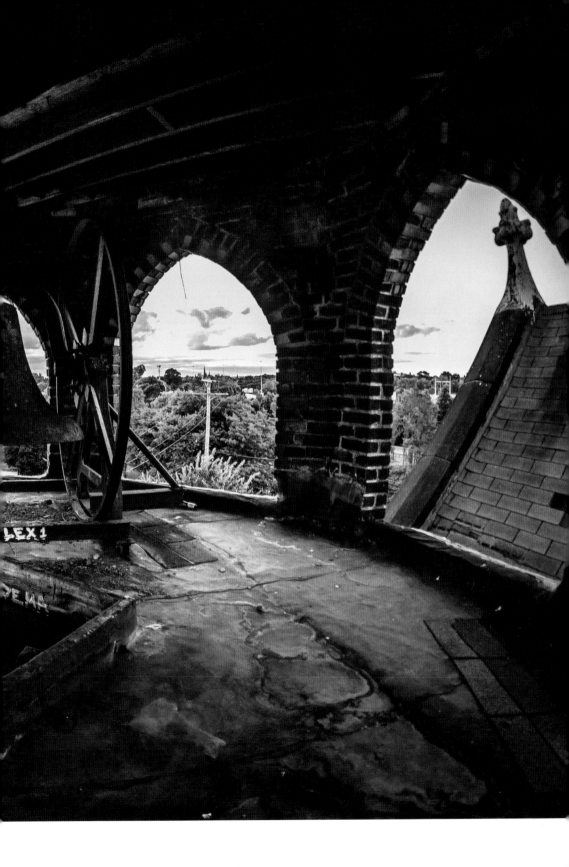

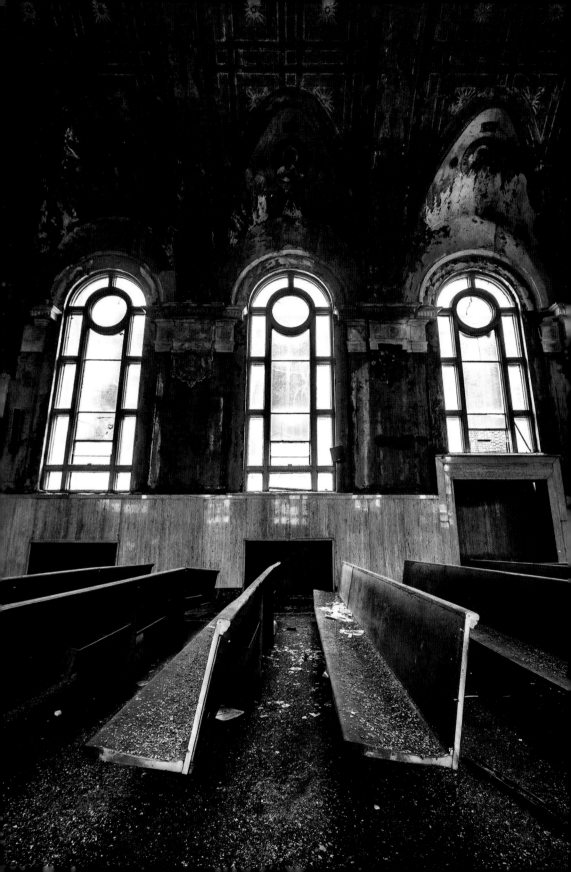

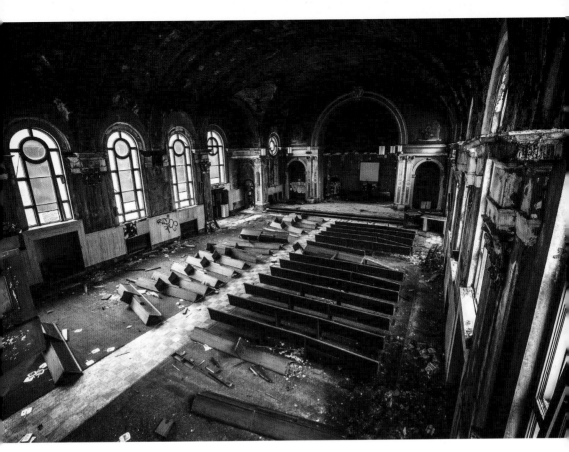

The original stained-glass windows were removed in 1990 and installed in a different church. (2018)

Opposite page: This catholic church was built in 1925. The building replaced an older one, which had been consecrated in 1903. Of all of the city's many vacant church buildings, this one is arguably the most beautiful. (2018)

Next page: The pews have since disappeared. (2018)

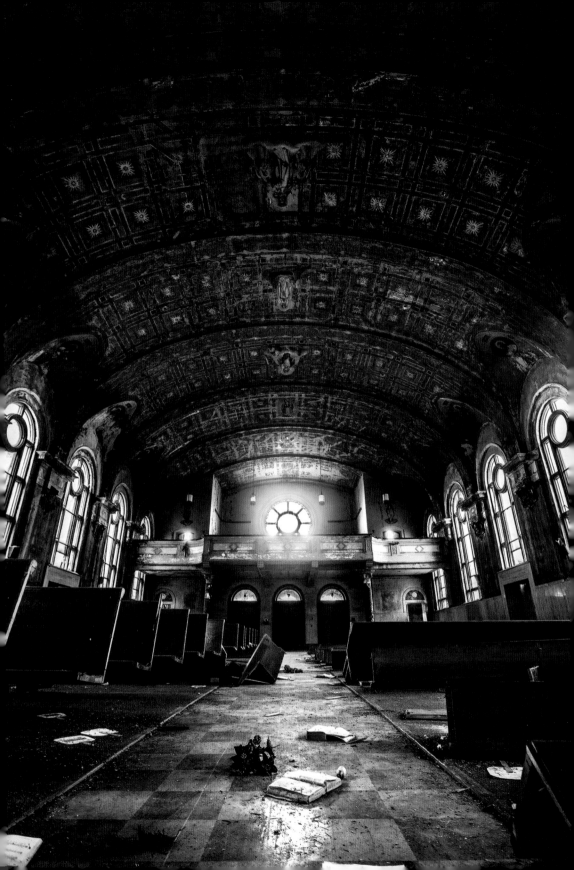

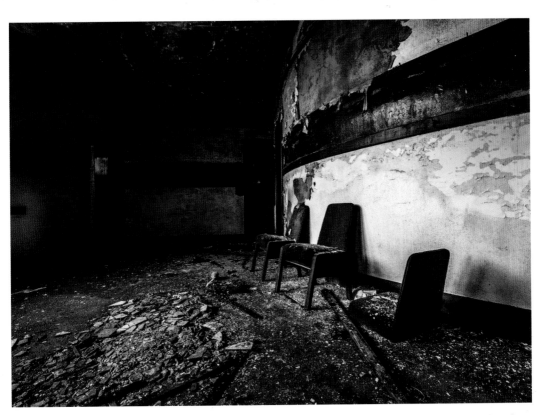

It's sad to see such beautiful places fall into disrepair. (2018)

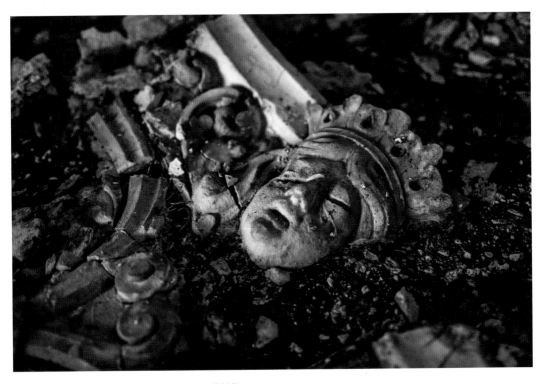

A plaster face stares up from the floor. (2018)

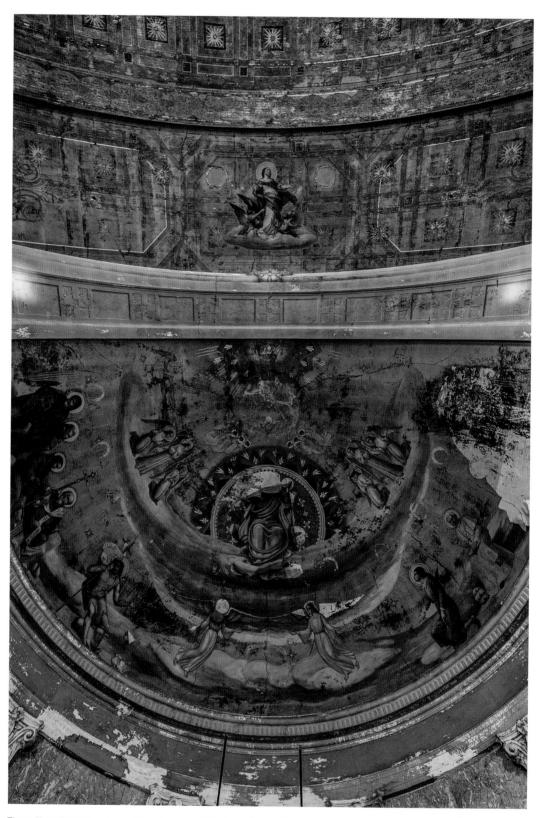

The ceiling of this church must have been breathtaking in its day. Now it is slowly fading and peeling away. (2018)

6

ODDS AND ENDS

There are plenty of unique abandoned structures in Cleveland, which is great because factories can start to all look the same after a while. Finding a recreation center with a graffiti covered lap pool, or exploring the city's beautiful subway tunnels, can be a nice break from the concrete and brick of the many old industrial sites. Other places are almost boring in appearance, but hide amazing secrets inside. Such is the case with a small relatively modern looking building that sat along the river in The Flats. I cannot tell you how many times I had ridden my bike past this place without ever truly seeing it, but when a friend of mine called and said I needed to meet him there, I knew exactly the place that he was referring to. Within ten minutes I had scaled the wall surrounding the building and was inside, dumbfounded by what I was seeing: boxes upon boxes of carnival sideshow figurines, nearly life-size and almost certainly handmade. I have seen plenty of bizarre objects in abandoned places, but nothing like these. A place that I had never paid much attention to ended up giving me one of the greatest rewards.

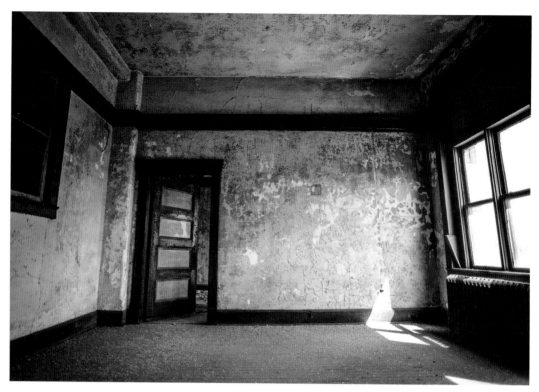

Built in 1898 as a depot for the Cleveland Terminal & Valley Railroad, which was eventually bought by the Baltimore & Ohio. (2014)

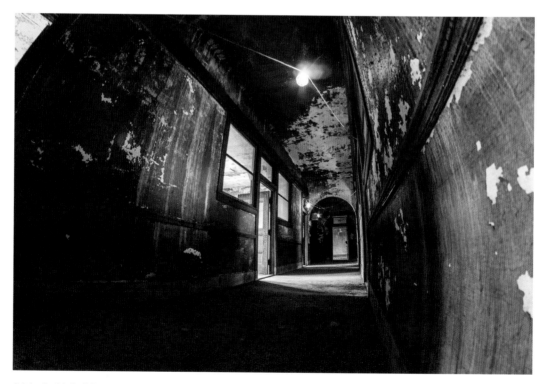

Originally this building had a clocktower, but it was destroyed by fire. (2014)

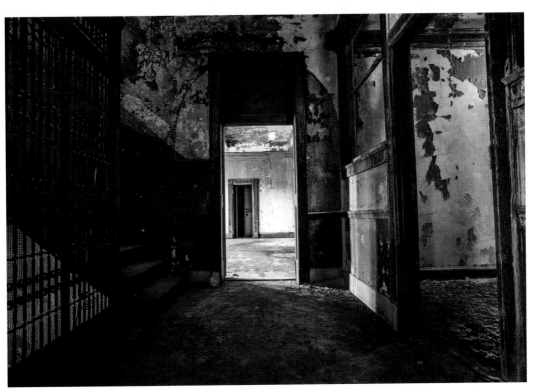

The depot served passenger traffic until 1934 when the Cleveland Union Terminal took over passenger service and the old depot was turned into a freight office. (2014)

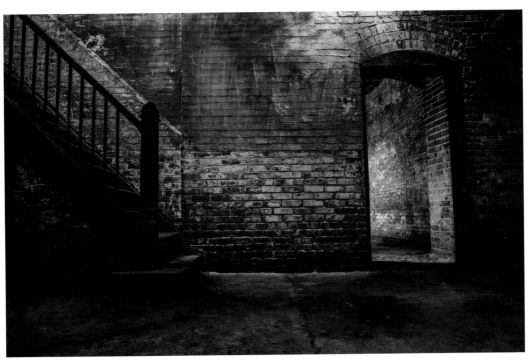

The depot had been on the top of my list of must-have buildings for almost ten years before I finally had the opportunity to explore it. It is a historic treasure, and I hope to one day see it restored. (2014)

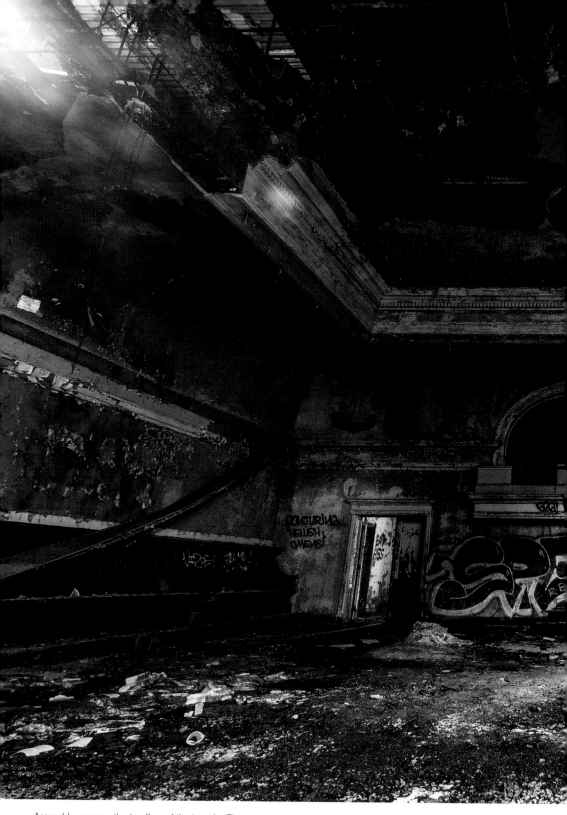

Assembly room on the top floor of the temple. There was also a large hall in the basement, and one on the first floor as well. (2018)

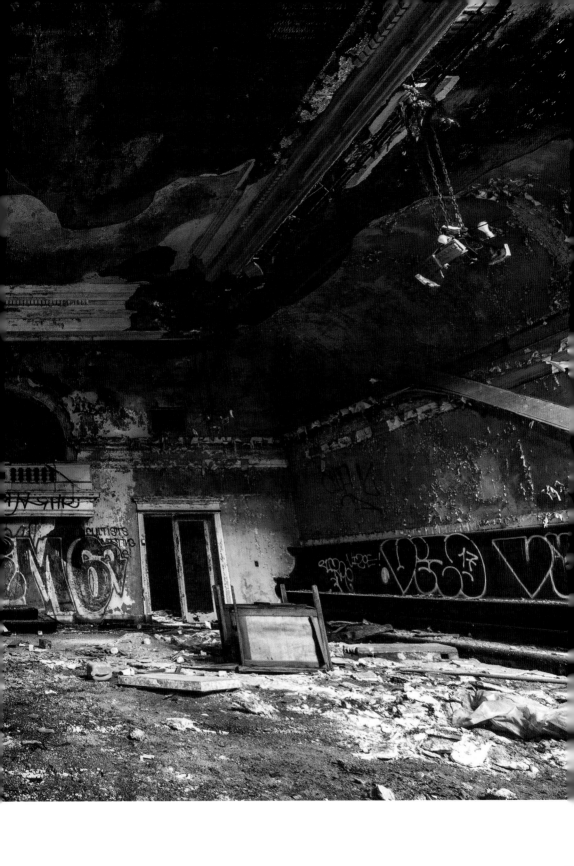

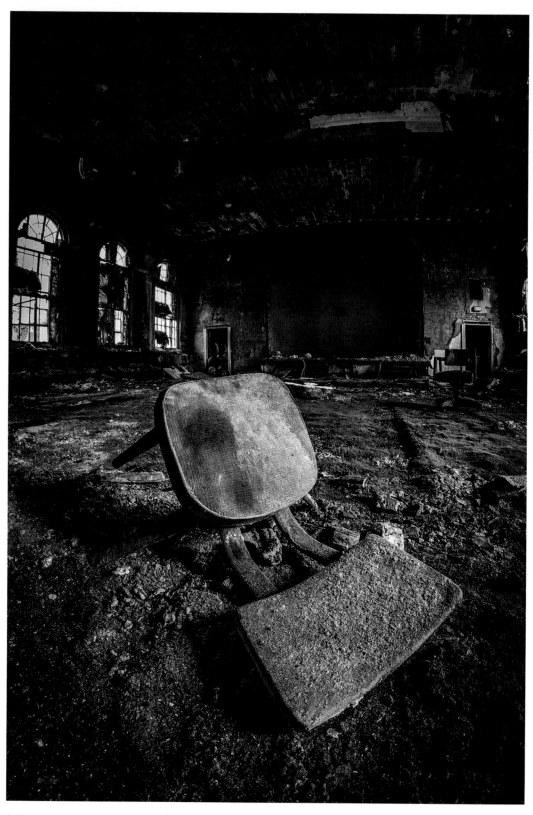

A Masonic temple, built in 1916, and designed by architect William J. Carter. (2014)

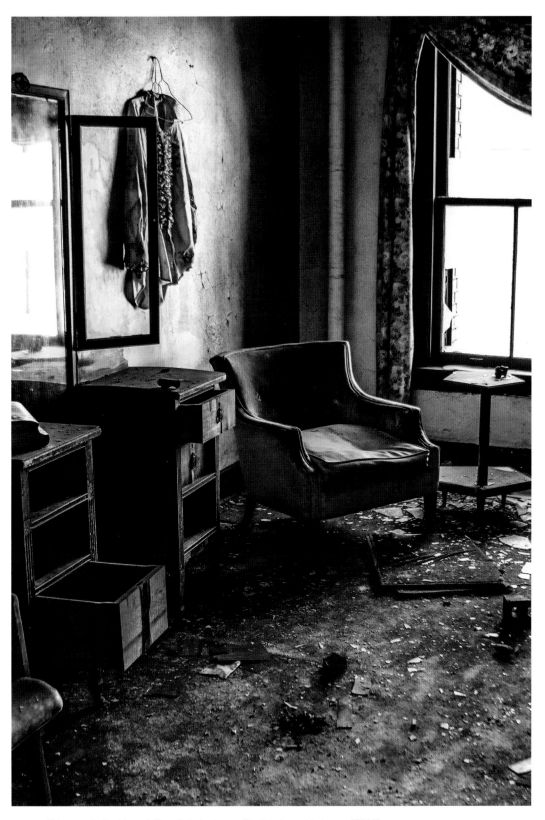

This room in the Masonic Temple looked more like it belonged in house. (2010)

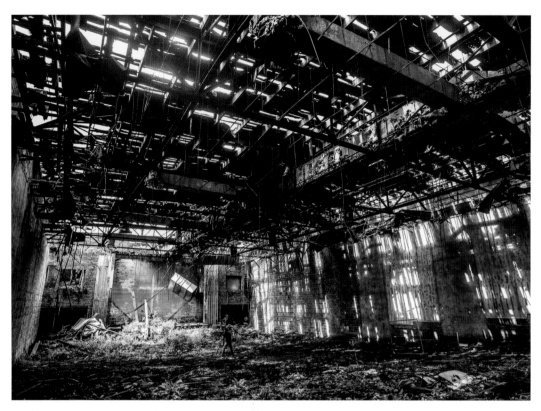

An old theater that was converted into a church. I hadn't expected to see so much vegetation upon entering. (2014)

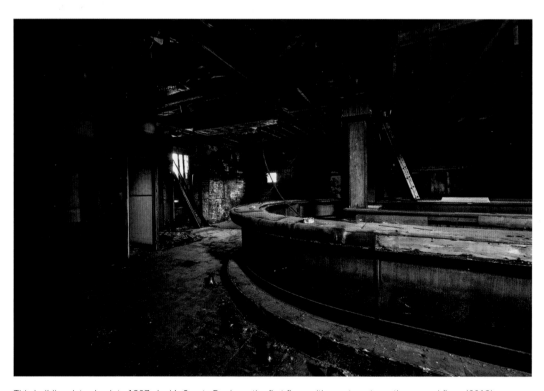

This building dates back to 1907. Jack's Sports Bar is on the first floor, with apartments on the second floor. (2018)

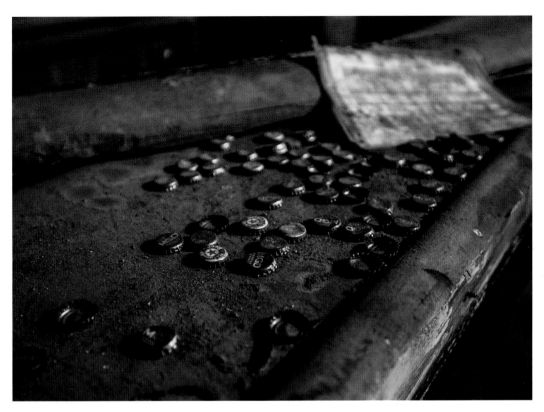

Bottle caps scattered across the bar. (2018)

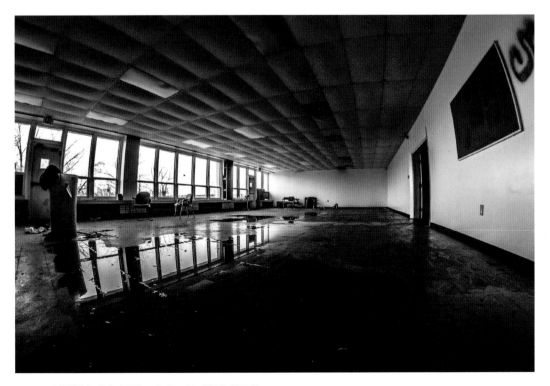

A YMCA built in 1955 and closed in 2006. (2015)

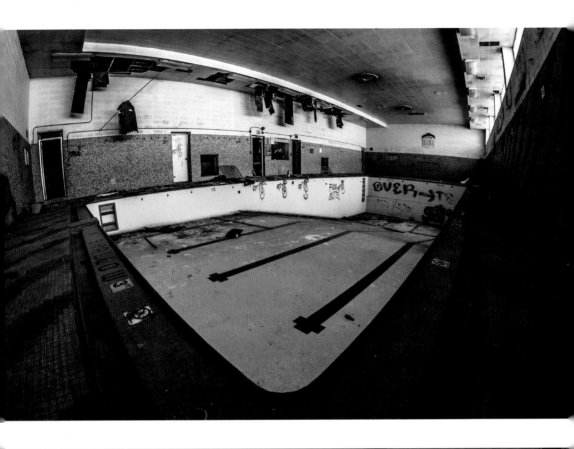

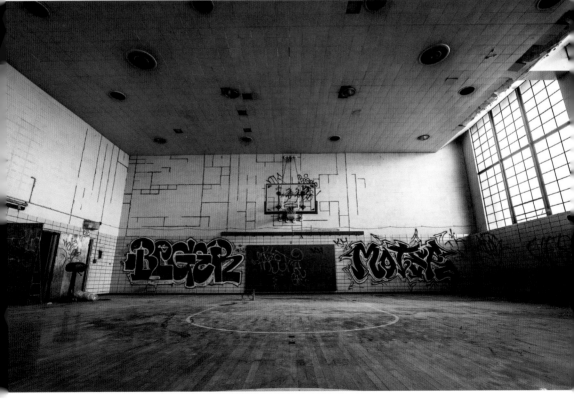

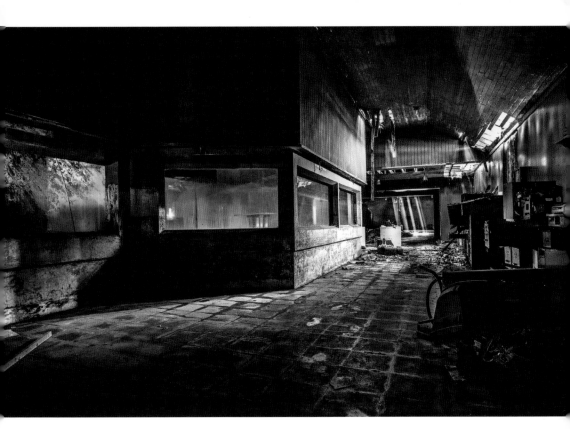

Empty tanks in Cleveland's original aquarium. When it opened in 1954, it had fifty exhibit tanks. In 1967, a new wing was built which tripled the size of the aquarium. In June of 1985, the aquarium closed. (2014)

Opposite above: The YMCA's swimming pool before being completely covered in graffiti. (2015)

Opposite below: A gymnasium in the YMCA. (2015)

Next page: The Aquarium was originally built as a bathhouse. This octagonal section was added in 1967. (2014)

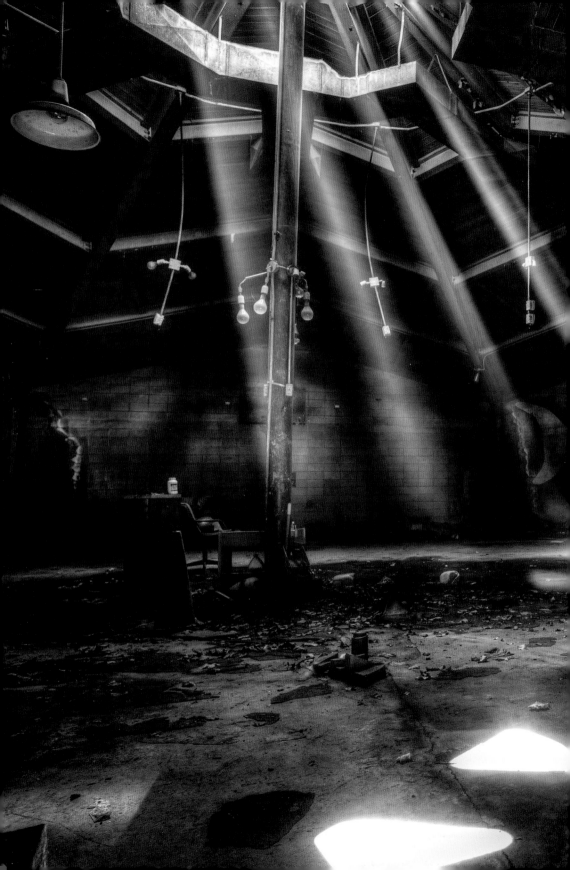

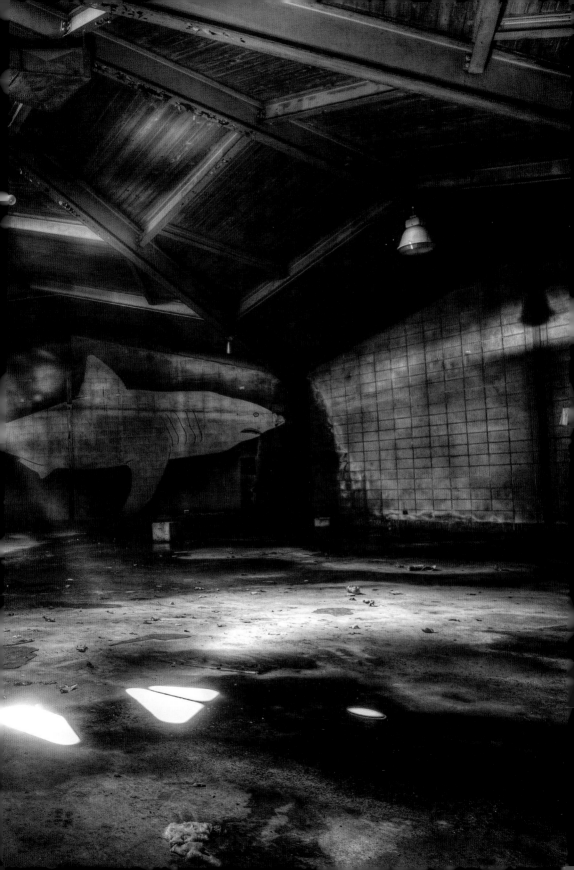

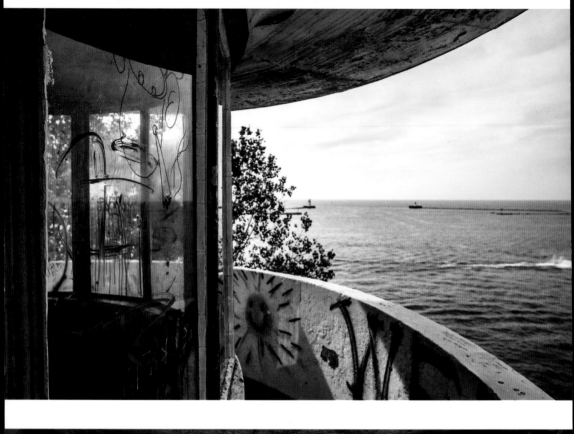
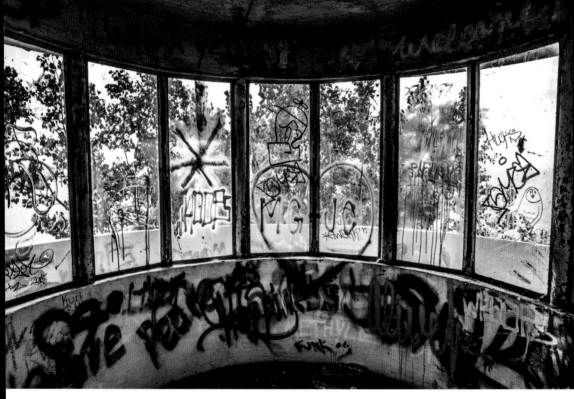

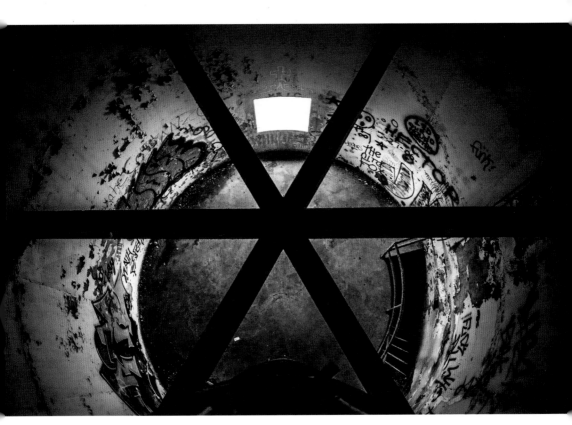

Today restoration work is being done and parts of the complex are already in use. (2015)

Opposite above: Built at the end of a pier off Whisky Island, this Coast Guard station opened in 1940 and was in use until 1976. (2015)

Opposite below: The Coast Guard station was designed by J. Milton Dyer. Dyer was the architect behind dozens of buildings in Cleveland, including Cleveland City Hall and the abandoned Warner & Swasey Observatory. (2015)

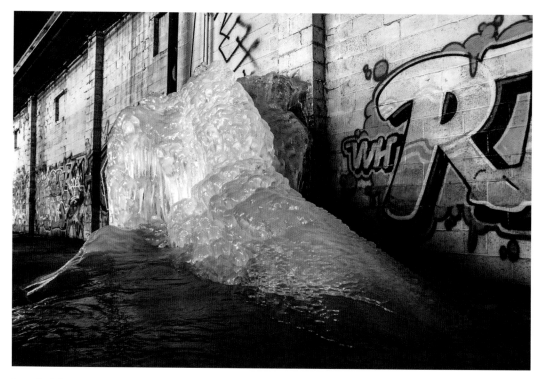

Some buildings can be frustrating, because they end up serving so many different purposes over the years that their original intention is difficult to track down. This old building on the West bank of the river still had running water, and each winter a leaking pipe would create these massive ice sculptures. (2011)

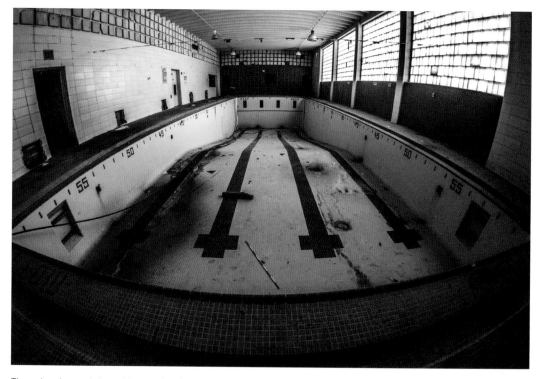

The swimming pool at an old recreational center on the city's east side. (2015)

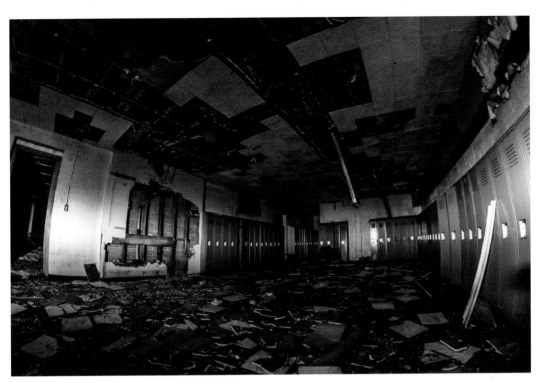

The locker room of the abandoned rec center. (2015)

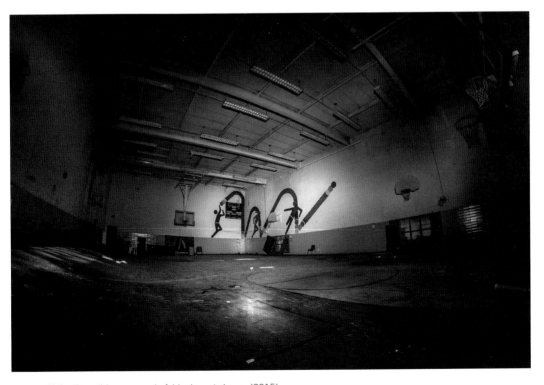

At the time, this gym was in fairly decent shape. (2015)

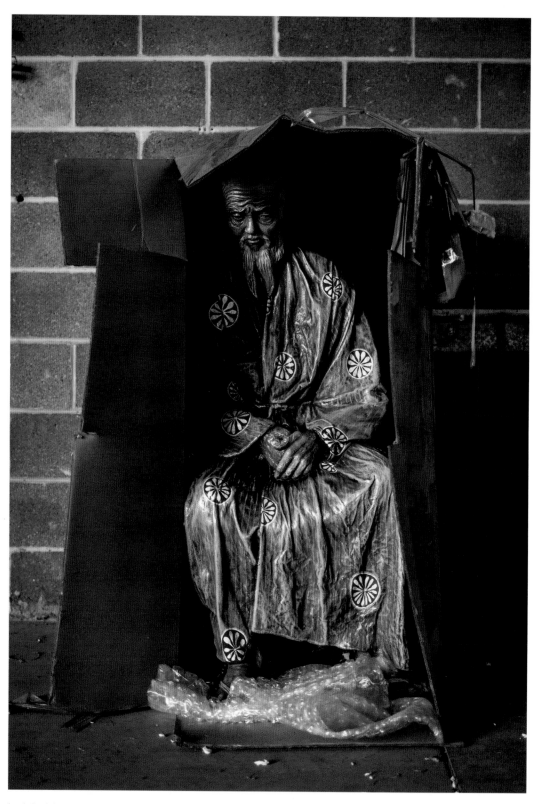

I only had the opportunity to photograph this building once before it was demolished. It was a very unassuming building and I've never been able to figure out what its intended use was. (2013)

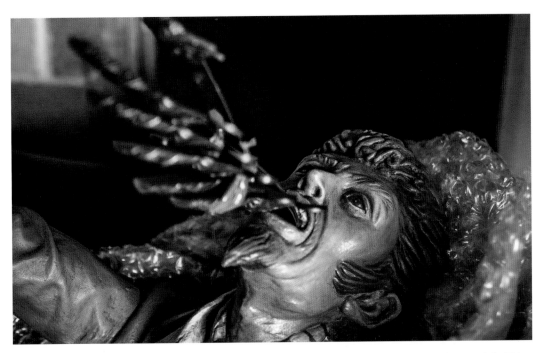

The most interesting thing about this location were the boxes of carnival-type figurines. The first floor was full of them. They appeared to be handmade. I truly hope that they were salvaged and didn't end up hauled away to a landfill with the rest of the building. (2013)

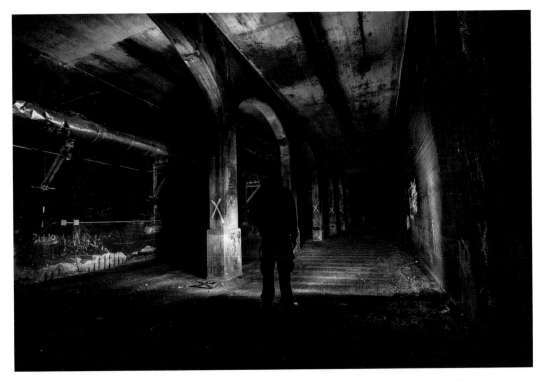

Cleveland's abandoned subway runs from the western end of Superior Avenue, over the Cuyahoga River on the lower deck of the Veteran's Memorial Bridge, and then splits into two separate tunnels, with one continuing west along Detroit Avenue, and another that heads south down West 25th Street. (2018)

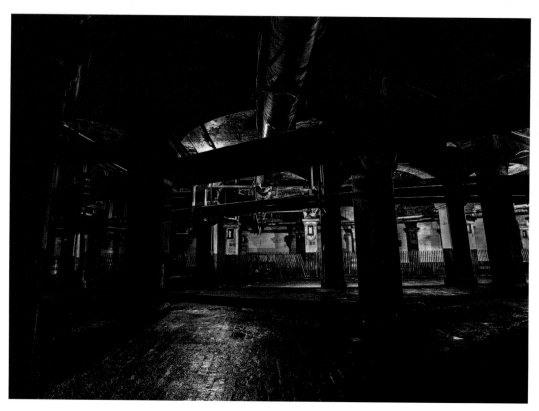

These tunnels were used by streetcars instead of actual train cars. (2018)

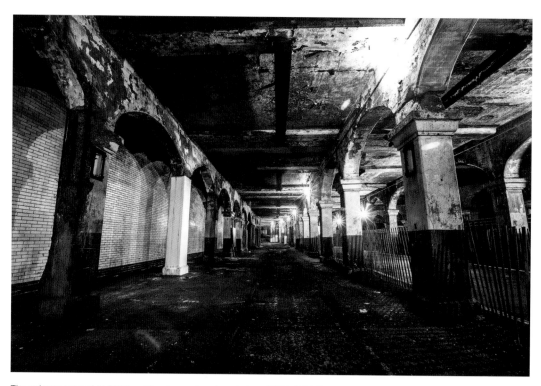

The subway opened in 1917 and has been abandoned since 1954. (2018)

FINAL THOUGHTS AND EXPRESSIONS OF GRATITUDE

I never started exploring abandoned buildings with any sort of goal in mind. I began exploring because I enjoyed the adventure. It pushed me to become a better photographer. I made a lot of friends and learned about my city's history. Looking back, I can see how much exploring has shaped my life and brought me to where I am today. It is something that I have no intention of ever giving up.

While I would love to thank each and every person that I have ever explored with, there are simply far too many of you to list. Jake, thanks for helping with research and for always being down to look for new places. Brandon, Jason, thanks for all the good times. The original crew, it was a blast. Special thanks to Garrett, whose gut instincts got us out of trouble on many occasions. To my grandpa, thank you for teaching me to respect and honor history. Kaylah, thank you again for all that you do for me. Your unwavering support means the world to me. And finally, thank you to the city of Cleveland. There is nowhere I would rather be.

ABOUT THE AUTHOR

JEFFREY STROUP has been exploring and photographing Northeast Ohio's abandoned and neglected locations for over fifteen years. His passion for photography and love of history has led him to explore abandoned buildings throughout the country. His work has been featured on Live on Lakeside, *Scene Magazine*, and The Weather Channel. He currently lives in the Tremont neighborhood of Cleveland with his wife, Kaylah. Follow Jeffrey on Instagram at jeffreyrstroup or visit his website at www.stroupphoto.com.

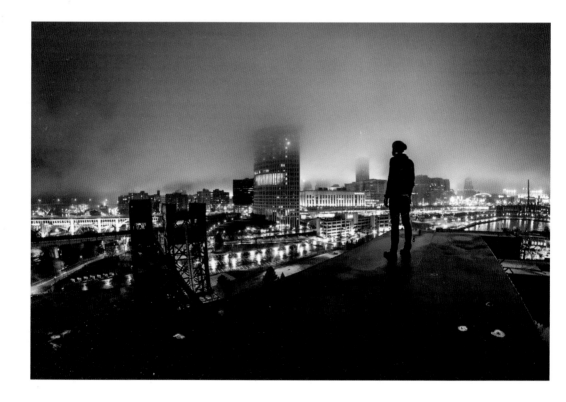